CW01176958

JEFF STAPLE
NOT JUST SNEAKERS

Jeff Staple
Not Just Sneakers

Section 1

**Origin
Story**

17

Section 2

Staple
Communicating
Through
Fashion

73

Section 3

Reed Space
Communicating
Through
Retail

114

Section 4

**Partnerships &
Collaborations**

133

Nico Reyes

"This is the dedicated to the ones who kept frontin'."

But more importantly, this is dedicated to
the ones who were with me shootin' in the gym.

The people who believed from day one,
in a vision that wasn't ever seen before.

My life partner and soul mate, Sawako.
My mom.
My crew, Miguel, Anthony, Jean, Sonia.
And my guard dog, Prius.

A long time
Lower East

ago, in the
Side.....

"There's a footwear frenzy going on
 in the city right now.

A special sneaker made just for New York is in such high demand, people are fighting to own a pair of these things."

"Kids were piled up against the fences
 like it was a soccer game — I can't believe this.

*I was actually fearful for the safety of the people here ... the staff ... myself."

"It was just, you know —
 it was scary at times."

"*Everyone's got their passion and their vice,*

 and for this small subculture ...

"...it's sneakers."

JEFF STAPLE

PIGEON POOPED: Cops try to control the crowd of people waiting Orchard Street yesterday after a riot broke out. Nike made only 150 p

NOT JUST SNEAKERS

Rizzoli
NEW YORK

New York · Paris · London · Milan

in line trying to snare a pair of Nike Pigeon (NYC) Dunk sneakers on
of the shoes, which were going for $1,000 on eBay.

"Everyone knows the story of the greatest sneaker of all time — the Pigeon Dunk. However, very few people know how STAPLE, the brand behind it, came to fruition. STAPLE's story didn't begin with the Pigeon Dunk. It didn't begin with a brand, and you might be surprised to find out that it didn't even begin with a formal art education. To understand the very essence of STAPLE, we have to travel much further back, to a time before streetwear and sneaker collaborations even existed. Every great story has a humble beginning, and the origin story of STAPLE starts in the early '80s in New Jersey.

When I was a kid, I was infatuated with the idea that a brand could mean something more to people than just a product. And I was obsessed with trying to figure out the hows and whys when this actually happens. If you put those things together, you get "CONCEPT" and "EXECUTION" — which is the foundation for every great brand that's ever existed. But back then, I was definitely way too young to understand any of this! So this is where STAPLE's story begins ... from childhood sketches to global brand. Started at the bottom now we here...."

— Jeff Staple

ORIGIN STORY C. 1975

ORIGIN STORY

18

ORIGIN STORY

ORIGIN STORY

The Early Years

20

ABOVE: *Early sketches I made as a child paying homage to one of the few heroes I had growing up — the NINJA.*
OPPOSITE: *My interest in brands started very early on. The Hulk, Superman, Meat Loaf, Travolta, Miller Beer, (who we would eventually collaborate with!). I even had a Playboy Bunny on my sweatshirt!*

When you grow up just 45 minutes away from New York City, as I did, you experience an interesting contradiction. Native New Yorkers tend to naturally feel like royalty — like they're preordained for greatness because of where they were born. I am not a native New Yorker, but I was constantly exposed to NYC's incredible spirit because of my proximity to it. I could feel the city's energy; however, I was still an outsider because I didn't grow up in one of the five boroughs.

New York City is the greatest city in the world. Sure, New Yorkers live in New York City, but New York City also lives inside New Yorkers. In my opinion, it's the only city that operates this way. NYC is like a living, breathing organism. It embraces you, but it also fights you every step of the way. It champions its heroes while simultaneously expelling people it doesn't need. As an outsider, I had to climb a metaphorical wall to get in. And after getting across that wall, I still had to prove that I belonged there to gain acceptance. It's absolutely true what they say — if you can make it in New York City, you can make it anywhere in the world.

I didn't fully understand the unique, location-based perspective I had as a kid, but it certainly played a major role in my career and in how I developed the hustle mentality that has stuck with me all this time.

I wasn't aware that graphic design, branding, advertising, and product design were career options

Early sketches show that I had a strange obsession with brands and the way things worked. I was thinking about new modes of transportation for people in different age groups. I was thinking about new designs for Swatch. And then of course my strange 10 year old Achievement Award for Best Work Habits (Boy).

until my second year of college at New York University. My family was in a financial situation that required me to earn my own money to do what I wanted to do, including paying my way through college. At the age of 12, I started working many different part-time jobs at the same time, and I continued to do so until the day I founded STAPLE.

One of my first jobs was at a film shop that developed photos in an hour. I was the kid in the back dipping my hands into chemicals to develop the film. At one point, I worked at a video rental shop. If you didn't rewind the VHS tape when you returned them, you would get penalized with an extra charge. That's where the phrase "Please Be Kind, Rewind" comes from. I was the kid that rewound videotapes if people didn't rewind them. I would sit there and stick VHS tapes in a machine and hit "rewind," boxes at a time. I delivered pizzas, bussed tables at a Chinese restaurant, worked at The Gap and The

Music was always a passion of mine from a young age. Here I am trying my best to DJ using mostly 45s! And of course, my Porsche and Lamborghini posters are close by for inspiration.

My father and me in Little Tokyo, Downtown LA. Even at this early age, sneakers were so important to me. Note the crisp Jordan 6s and my pin-rolled jeans so people could clearly see the shoes.

Athlete's Foot in the mall, swept hair at a hair salon — you get the idea.

When I started college at NYU, I had to keep working. I wasn't looking for work based on interest — I was just looking for the job that paid the best, even if it was by just a few cents. Eventually, I found a data entry clerk job at Noble Desktop Publishers, a traditional graphic design studio focused on typography and photo manipulation for paperback books, magazines, and manuscripts. It paid one dollar more an hour than what I was making at Paragon Sporting Goods, and I was so excited.

The studio turned into a school to teach people how to use new graphic design programs after hours. I worked there in the mid-90s during the digital revolution, when designers started to shift focus from the physical layout process (film, negatives, tape, utility knives, and light boxes)

THE EARLY YEARS — ORIGIN STORY

Brand obsession from a young age. Ellesse tennis, Air Jordan, Nike Flight, and attempts to catalog as many Nike Air footwear styles as possible. And me. With hair.

24

to learning digital graphic design programs, such as QuarkXPress, Photoshop, and Illustrator. This night school was the studio's way of capitalizing on that shift. Many working professionals who took our courses had never worked on a computer before, so they started by learning basic tasks like creating folders and saving files.

As a data clerk, I answered phones, wrote down and relayed messages, sent out promotional mail, licked stamps — a lot of administrative shit. But as I sat at my desk, I would observe the rest of the staff and watch them in action. I saw all the different sides of the design process, from layout creation to working with printers. I already had an interest in the graphic design world, and I finally got to peek behind the curtains for the first time.

At the time, I was a journalism major at NYU, but because of my experience at Noble Desktop Publishers,

I wanted to explore graphic design as a career option. At the time, NYU didn't offer any design courses that I could take. I was disappointed because I was paying quite a bit of money for tuition, but I couldn't learn what I wanted to learn.

I wasn't super passionate about journalism. I liked creative writing, but my parents frowned upon me exploring that as a career path. At the time, there was a Chinese journalist on ABC named Connie Chung. When my immigrant parents see successful Asian people working in a field, they believe it's okay to explore what they do as a viable career path. If they don't see somebody Asian working in a particular industry, they believe it's impossible to make a living in those positions. When they saw Connie Chung, they said, "Okay, we get it. She's on TV. That means she's rich. You can try to be Connie Chung." That was their logic.

Childhood sketches focused on the way things worked down to the tiniest little details. Safety buttons, acronyms, plumbing systems, reference codesMy brain hurts seeing this today.

I became so enamored and enthralled with my job at Noble Desktop Publishing that the founder, Scott Carson, let me start doing graphic design work in addition to my data entry work. Scott was one of my early mentors. What I loved most about working for him was that his teaching style threw me right into the work in a way that never put me in over my head. When we worked on a new project together, he would start by asking me to do just copy edits. Then, he'd ask me to add a single photo to the layout.

Eventually, he had me fixing photos in Photoshop. He gave me the graphic design arsenal slowly but surely, one step at a time.

I eventually became an instructor at the night school, which made me realize that I also really enjoyed teaching. When you prepare to teach a class, you have to be sure that you can answer any question students might throw your way. It's intimidating to walk into a class where your students might know more

The interior of the year 2001 outdoor-camping tent.

"As I kept teaching, my own skills leveled up. It's a cheat code I still use to this day. Here's the secret: Mentors can actually learn just as much as their mentees."

than you, which pushed me to keep expanding my own skill set. As I kept teaching, my own skills leveled up. It's a cheat code I still use to this day. Here's the secret: mentors can actually learn just as much as their mentees.

When I discovered graphic design at Noble, it was also a pivotal moment in the design industry because it was during the transition from hands-on to digital. That transition will never happen again. If I were five years older, I would have only learned analog processes, and I would have had to play catch-up with these new digital tools. If I were five years younger, I would have never touched a light box or drafting paper. I was lucky enough to enter the field at a time when I understood both the inherent benefits of learning old analog and new digital methods.

After two years at NYU, I was confident that graphic design was what I wanted to pursue. I felt a

calling, but I was already paying tens of thousands of dollars for a school that would not fulfill what I wanted. Lo and behold, Parsons School of Design, one of the best design schools in the world, was only 14 blocks north of NYU. I would pass Parsons during my commute, looking in the window and seeing what the students were doing. It was so close, yet so far.

If I had dropped out of NYU and went to Parsons, I would have had to completely start over because none of my journalism major credits applied to a foundational art school. I also wasn't sure if I would get into Parsons. I didn't even have a portfolio. Kids applying to Parsons were already doing figurative drawing and high-level type shit, but I literally only had my childhood drawings. I didn't have anything to show from high school or from NYU. It was pretty bad.

I ended up getting accepted because my drawings and interview showed a promising thought process.

ORIGIN STORY

THIS SPREAD: Sketches for a fantasy Disney-like resort, modes of transportation by rail and water, and even imaginary sports.

NEXT SPREAD, FROM LEFT: Plans for the perfect lemonade stand down to the feet and inches.

Manually created record-keeping of all music charts. For some reason, I was producing handmade spreadsheets at 11 years old!

The Perfect Lemonade Stand

Designer Jeff Ng

(L) 60" plywood —
(w) 6" plywood — > 5 ~~acres~~ pieces

3" plywood — 2
(L) 5" plywood — 2
(w) 10" ———— 2

(w) 2' plywood
(L) 2½' plywood > 2

15-20 nails

Lemonade 10¢

storage space (under)
storage space (under)

5"×10' 60" 5"×10'
2'×2½' 60" 2'×2½'

Jeff Ng

The Top 3 of Main Charts. 4/13/86.

①= most gains this week.

Category	The Artist-Song
Adult Contemporary	① Overjoyed - Stevie Wonder
Top Black Albums	② Tender Love - Force M.D.'s
Top Black Singles	③ These Dreams - Heart
Hot Dance/Disco	① Sade - Promise
Hot 100 Singles	② Janet Jackson - Control
Top Pop Album	③ Whitney Houston
Songs With a Great FUTURE!	① Kiss - Prince and the Revolution
	2. Going in Circles - The Gap Band
	3. What Have You Done For Me Lately - Janet Jackson
	(Dance/club play)
	① Kiss (Remix)/Love or Money - Prince and the Revolution
	2. What Have You Done For Me Lately - Janet Jackson
	③ Whenever You Need Somebody - O'chi Brown
	(Disco (12 inch Singles Sales))
	① Kiss (Remix) Love or Money / Prince and the (Remix) Revolution
	2. I'm Not Gonna Let - Colonel Abrams
	③ I Can't Wait - Nu Shooz
	① Rock Me Amadeus - Falco
	② Kiss - Prince and the Revolution
	③ Manic Monday - Bangles
	① Whitney Huston
	2. Heart
	3. Sade - Promise
1st week at 49 →	① Live To Tell - Madonna
1st week at 88 →	② Hands Across America - Voices of America
3rd week at 29 →	③ Greatest Love of All - Whitney H.

Jeff Ng

"This was my first glance into how I could merge and apply my thoughts on graphic design, typography, hip-hop culture, politics, and creative storytelling, but I still needed a delivery mechanism for my story."

> see Dick drink
>
> see Dick drive
>
> see Dick die
>
> DON'T BE A DICK!
>
> — Jeff Ng

I saw a lot of people in my family and my friends' families affected by alcohol.

I initially chose product design as my major because I was interested in the process, but I struggled quite a bit in my first semester. Early product design courses require a lot of handwork, like building models with foam core. As you can probably see from my work, I'm more of a thinker than a craftsman. After learning more about my interests, a professor eventually advised me that I was in the wrong major and that I really needed to study communication design or graphic design.

It made sense. Everything I loved was 3D, like sneakers and clothing, but what I was actually in love with was the branding of those objects — the ads, hang tags, stickers, boxes, etc. 3D objects were merely another medium for expressing ideas.

In my room, I had posters and advertisements everywhere. For example, I really loved John Jay's work for Wieden+Kennedy. He made amazing ads for Nike NYC. I would steal the print ads from the subway and put them up on my apartment wall. Switching to the Communication Design Department was immediately like fitting a round peg in a round hole — it just clicked.

ORIGIN STORY

Inspirations

34

1 19 Cutouts from Sports Illustrated: These were the GOATs. The Gods. I just wanted to emulate some small sliver of whatever I could from them. And that usually meant the shoes. I'd cut all these images out of the mags and pin them to my wall.

29 Zoo York sticker that was printed on actual skate grip tape — DIY before DIY was cool.

28 Futura exhibition invite at Colette from 2001. Too dope.

27 Kevin Lyons print: I love how Kevin extrapolated a hardcore hip-hop lyric and made it this dope graphic/illustration. Typography has always been a big inspiration for me.

26 Writer's Bench sticker: Another early streetwear brand that grew up in the same era as STAPLE. We printed shirts at the same spot (shout out Prographix!).

25 X-Girl business card: X-Girl was the female division of X-Large. For the most part, it was a Japan-only outfit but they finally opened a shop in NYC in the early 2000s.

24 The OG PNB Nation sticker with the dead pig. In my opinion, the most important and influential streetwear campaign ever.

2 Double RL: To me, one of the greatest brands to ever exist. It is Ralph tho!

3 The rapper Mad Skillz's sticker: So much to unpack in just one "simple" sticker: MC-ing, illustration, graf hand styles, typography, and graphic design.

23 An old photo I snapped of the elevated subway line in NYC. Even before I really understood graffiti or viral marketing, I always saw clean trains as a beautiful blank canvas.

22 Clear was the third album by English electronic music group Bomb The Bass (1995). I wasn't the biggest fan of electronic music, but I did love good graphic design when it came to music packaging.

4 Common Sense, later known as Common: One of my favorite lyricists of all time. Would later have the honor of designing his One-Nine-Nine-Nine album cover (see page 246).

5 My close friend Riko Sakurai is like the Bobbito Garcia of Japan. She was the person who brought hip-hop culture to Tokyo. She'd eventually become President of Def Jam Japan.

21 Doubledown sticker: An early streetwear brand that grew up in the same era as STAPLE. Just trying to figure our shit out. (Remember the subway train T-shirts before the MTA shut them down and bootlegged the same exact idea?)

ORIGIN STORY

6 Powell Peralta: I was infatuated with skate design as much as hip-hop design but in the early '90s, the subcultures were not friendly like they are today. I remember back then in NYC, I was shy about sharing my love of skateboarding. I know if I had grown up in LA, it likely would've been the other way around.

7 The infamous manifesto from Shepard Fairey, creator of the Andre the Giant sticker graffiti campaign. Back in the day you would get this sticker by sending a dollar in cash to him in the mail with a self-addressed stamped envelope. He would send you back a sticker along with this manifesto about Andre the Giant.

8 These hilarious dice were made by Tibor Kalman's firm M & Co. I was obsessed with typography, and I loved that the legendary Tibor Kalman just let the dice decide! I remember my friend Diane got a job at M & Co. and I was so utterly jealous.

9 Precision Type Font Reference Guide Version 5.0 – the typographers BIBLE right here.

10 During the early years of STAPLE, I sponsored DJ competitions, rap battles, and breakdance exhibitions. These were the foundational seeds for what would be known as "street culture."

11 AIGA flyer from 2000 promoting the importance of design. The controversial topic during this time was a discussion of how George W. Bush managed to steal votes from Al Gore based on a deliberately confusing design layout in the voting ballots.

12 Nike x Acronym Flight Suit. A gem of an archive piece. Nike & Acronym held a paintball tournament in Shanghai to celebrate the release of the Acronym Prestos. I think I was on the same team as Errolson Hugh. (Founder of Acronym)

13 Classic Triple Five Soul sticker. You can see the level of design and refinement that came from something also heavily rooted in hip-hop culture.

20 PNB Nation sticker.

17 Platform.net sticker: The first multi-brand streetwear e-commerce platform dating back to 1998! Think about how many streetwear e-commerce sites there are today and how ahead of their time Platform was. Shout-out Tina and Ben!

18 Jeru The Damaja: Backpack hip-hop at its finest.

15 This invite speaks VOLUMES. A-Ron presents Gil Scott-Heron live at Joe's Pub (at the Public Theater). Lord Finesse on the wheels. Sponsored by Stüssy, Supreme, and SSUR. Dating back to 2000! How much more OG blood can you fit onto a 5x7 postcard?

16 Label NYC sticker: Label was founded by Laura Whitcomb in 1993. One of the first female streetwear(?) brands to do this type of apparel. Highly inspirational to me.

14 Nike Andre Agassi advertisement. Cutting out and collecting ads was my early mood board. Wieden+Kennedy did most of Nike's ads back then and I would eventually be able to meet and cross paths with John C Jay, partner and executive creative director WK. Full-circle moment!

35

ORIGIN STORY

PNB Nation Internship

36

I simultaneously worked part-time at Paragon Sporting Goods and Noble Desktop Publishers while studying at Parsons full-time. Around the same time that I switched to the Communication Design Department, I landed an internship at PNB Nation on top of my other responsibilities. PNB Nation was one of the earliest OG streetwear brands. We all know Union as an important streetwear pillar and Nike collaborator. But many people don't know that, before Union moved to LA, it was in SoHo, New York, on West Broadway and Prince Street in a store no bigger than 300 square feet. The original store sold a small handful of brands, including Futura and Stash's brand Project Dragon, Triple Five Soul, Union's in-house brand, and PNB Nation.

The PNB Nation founders, Brue McHayle, Sung Choi, Zulu Williams, and West Rubinstein, were traditional graffiti artists, so they were all very hands-on with the design process. Since I had graphic design experience, I helped execute some of the computerized work like creating design layouts, prepping print

files, laying out line sheets, and making hang tags.

Interning at PNB Nation was such an essential step in my career because it was my first glance into how I could merge and apply my thoughts on graphic design, typography, hip-hop culture, politics, and creative storytelling. But I still needed a delivery mechanism for my story. I could have chosen photography, sculpture, or painting to convey this amalgamation of topics. However, working at PNB Nation inspired me and made me realize, for the first time, that I wanted my medium to be fashion.

THIS SPREAD: Early work from the archives of PNB Nation that I contributed to in one way or another. From art processing to layout to Photoshop work to packing and shipping! Seeing PNB's work today, three decades later, really makes me see that great design truly stands the test of time.

> Deflon Sallahr (RIP) told me he liked my T-shirt. When I told him I had made it, he asked if I wanted to sell a few of them in the shop. I was shocked.

Even though I was working three jobs at once, my mindset was still that of an art student. I had no capitalistic desire to make money. I was merely looking for a medium to let me tell the stories I wanted to tell. I had friends in college who were great artists utilizing different mediums to tell their stories — photographers, sculptors, illustrators — even great fucking knitters. They each had their own mindset and unique ingredients that they poured into their respective blenders to yield their creative work. They had their mediums, and I needed to figure out mine.

During my daily commute from Brooklyn to Midtown Manhattan, I paid attention to what people wore on the subway, the bus, and the street. Even though I was obsessed with logos and brands, I understood that even if someone wore a blank T-shirt, a team jersey, or a specific brand, it said something about them. They had to make a decision that morning to put that article of clothing on their body and say, "I will be represented in this way today to everyone that I encounter." They don't literally say that, of course, but it happens on a subconscious level every day.

People in urban cities — and what they wear — are exposed to thousands of eyeballs every day. To me, the power of the T-shirt, in particular, is incredible. If you can get one hundred people to wear a T-shirt you made, that is arguably more powerful than a billboard in Times Square. Instead of a static advertisement, you now have an army of one hundred ants moving around different parts of the city. It's much more guerilla and punk, if you will, because it's like infiltrating.

I quickly realized the strength of taking my creative ideas and expressing them using skills from my communication design major and graphic design experience, then applying them to articles of clothing as the medium for my message.

My program had access to a silkscreen lab, but because it was a print-focused major, no one taught us how to silkscreen print on textiles — it was only for paper printing. To me, though, there's a big difference between hanging an incredible piece of fine art you printed on a wall in your apartment and putting that same piece on a T-shirt and walking around wearing it in public. There's no question which is a more powerful delivery method. So I bought three blank T-shirts from Canal Street and brought them to the silkscreen lab at Parsons.

The instructor immediately disapproved, but he couldn't give me a reason why. He simply told me, "No, you can't do that." I hate it when people say you can't do something without giving a valid reason why. That's one of my pet peeves. I'm the type of person that if you can validate your decision, I'm cool with it even if I disagree with it. When someone tells me I can't do something without giving me a reason that makes sense, I instinctively want to prove them wrong. So that's what I did.

I had a close friend in the class who was an exchange student from Japan, and he was also enamored by hip-hop and downtown New York City culture. We decided to break into the silkscreen lab after hours to print on the shirts. We would leave the doors and windows unlocked before we left class, and then we would come back when the lab was empty. We brought our own inks and squeegees, so that we wouldn't be using the school's materials if we got caught. And then we'd print all night long.

It was addictive. The breaking and entering aspect was fun, and having the lab to ourselves was also dope. We had a renegade punk mentality. You told me no and couldn't give me a reason why, so now I'm doing it, and no one's getting hurt. So what's the big deal? We just put our ideas on T-shirts and gave them to our friends and fellow students.

We did this before influencer marketing and seeding existed. Brands weren't giving free clothes to influential people to rock to get exposure yet. It was an innocent and naïve endeavor. We had no ulterior motive and certainly no intention to go "viral." This was 1996! We just liked the idea that our friends would wear our work on the F train.

We experienced the same thrill that you get from tagging a train and knowing it will ride through the five boroughs for so many people to see. I made a T-shirt, and I gave it to my homie. How many people are seeing my design right now? That was it. I had no intention of starting a brand. I was very

It was the first order I ever received — and it happened on my birthday! So, as a business, my brand was literally born on the same day that I was born.

happy in school and juggling multiple jobs. Just a few years ago, I was toiling away at NYU, and now I was doing what I loved.

My life changed during my second year at Parsons in 1997, on my birthday, March 7th. My girlfriend at the time wanted to get her hair done in preparation for my birthday because we were going out to celebrate later. So I dropped her off at a salon in Chinatown. She wanted to get her hair done there because they know how to style straight-ass Asian hair. She told me to come back in three hours. So I walked around to kill time, wearing one of the shirts I had made by hand at school.

I went up to Lafayette and Houston in SoHo to the Triple Five Soul store. Triple Five Soul is one of the most important early streetwear brands that, alongside Ecko, paved the way for independent clothing brands to expand. They had dozens of employees — people were actually making a living working there. PNB nation was also successful, but it was only the four founders for a while. They didn't have an office with tons of employees. Triple Five Soul and Ecko were on another level.

So I walked into the Triple Five Soul store that day. The manager at the time, Deflon Sallahr (RIP), told me he liked my T-shirt. When I told him I had made it, he asked if I wanted to sell a few of them in the shop. I was shocked. It was the first order I ever received — and it happened on my birthday! So, as a business, my brand was literally born on the same day that I was.

Deflon's next question was, "What's the name of your brand?" I had no idea yet. I had to snap out of my excitement for a minute and come up with something.

The late '90s was considered the last golden era of hip-hop culture. There was a new interpretation of rap fronted by Jay-Z and P. Diddy, which propelled the image of poppin' bottles, private jets, spinning rims, and shit like that. That whole glamorous, Versace-esque lifestyle was born in this era.

On the other end of the spectrum, an anti-establishment movement against this new interpretation believed "real" hip-hop was based on four core elements: DJ-ing, MC-ing, graffiti, and B-boying. Nothing more, nothing less. This old-school sect believed that anything above and beyond the four pillars, like fur coats and video hoes, was not hip-hop culture. it was some other bullshit. Those two very different factions were operating parallel to each other.

Most urban hip-hop brands at the time were fronted by hip-hop celebrities, like Diddy with Sean John, Jay-Z with Rocawear, Wu-Tang with Wu-Wear, to name a few. These and other brands, like Perry Ellis America, Nautica, Tommy Hilfiger, and FUBU were aesthetically loud, in your face, and pretty gaudy.

I wanted to create something more subtle, thought-provoking, and nuanced. I wanted people to feel the artist's hand in my work, which is indicative of punk rock culture, skate culture, and the underground hip-hop movement. So I tried to bridge these ideals with hip-hop music and culture in a way that felt true to me.

I wanted my brand to represent the raw, essential elements of a culture, similar to how the underground hip-hop scene was based on the four pillars of hip-hop. When you think about essential elements you can't live without, the word staple comes to mind. Rice, for example, is a staple of Asian culture. So I decided to name my brand STAPLE.

When I got home, I designed the first STAPLE logo and made quick turnaround labels for the shirts. The labels were inspired by the instructions on disposable chopsticks that you get at Chinese restaurants — the three-part drawing that teaches you how to use them. I took the food out of the chopsticks in the illustration and inserted the STAPLE logo in its place.

Deflon loved the shirts. I sold them for $12 each, and he would sell them for $25. As I walked out of the store, he said, "Yo, let me know what else you got, Jeff Staple."

I literally jolted back and reacted with a confused, "What did you call me?"

He explained, "Your name is Jeff. I don't know your last

As I walked out of the store, he said, "Yo, let me know what else you got, Jeff Staple."

name, but your brand is STAPLE, so you're Jeff Staple."

To which I said, "Please don't call me that. I don't like it."

That was the first time someone called me Jeff Staple, and I hated it. Marc Milecofsky had built the brand Ecko, and now he's called Marc Ecko. I always wondered what would happen if Marc didn't want to do Ecko one day (which would eventually happen). It was just something I didn't want to deal with. But Deflon insisted and wouldn't stop calling me Jeff Staple.

"Nah, but you're Jeff Staple, bro!"

I remember thinking: *Please don't let that catch on, Please don't let that catch on....*

But, of course, it caught on.

Now people think it's my government name. People have booked flights for Jeff Staple, and I can't get on the plane because of it. People book hotel rooms under Jeff Staple, and I can't check in. I've considered legally changing my name to Jeff Staple. I was fighting tooth and nail on it, but Deflon, you won, bro.

The name Jeff Staple caught on to the point that Union was the second store that bought STAPLE. The streetwear scene back then wasn't as competitive as it is now. Union's manager, Vito, used to hang out with Deflon and the staff at Triple Five Soul. So, he eventually saw my shirts and knew who I was. Vito ordered 12 shirts for Union. He didn't want the same designs as Triple Five Soul, though, so I developed new designs.

At the time, James Jebbia of Supreme owned Union with his then partner, Mary Anne Fusco. When it was time for Union to pay me, the checks came from JAMCO, which stood for James and Mary Anne's Co. In addition to founding Supreme, James also owned Union and managed the Stüssy store in SoHo.

The Stüssy store used to be a duplex on Prince Street. The first floor was for retail, and the second floor was a loft used for office space.

James was always up there working. When customers came in, he would look down to see what was going on. Since I was a regular and he wrote checks to me, he would give me the nod. That made me feel so accepted by the culture — I felt like the streetwear god had already blessed me. Even though James wasn't as big of a household name as he is now, he still had so much influence on me when I started in the industry.

So now the two most influential stores in New York City were selling STAPLE, and I didn't even try to get into them. In addition to Triple Five Soul and Union, I also sold shirts at a hardcore graffiti store on West Broadway called Bomb the System, my friend Tony Bo Chan's skate shop on Avenue A called Swish, and Bobbito Garcia's store in the East Village called Bobbito's Footwork.

Bobbito had a Columbia University radio show with Stretch Armstrong every Thursday night from 1 a.m. to 5 a.m. that focused on the best underground hip-hop. He had a cult following and eventually opened Bobbito's Footwork, where he sold sneakers, vinyl records, and T-shirts. It was no bigger than 200 square feet. So I was selling STAPLE between these five New York City shops. The orders were still small enough that I continued breaking into Parsons to make the shirts.

Then one day, someone named Gorie called me from Tokyo. He said he got one of my shirts at Union and that he loved it and wanted to buy more — a THOUSAND more. I held the phone and screamed. Someone in Japan wanted to order one thousand shirts!!!!!

I had already started rethinking my process because I was juggling orders for five stores while still breaking into school to fulfill them. I would make charts to outline my process and try to perfect it. I used the same thought process as when I sketched my ideas as a kid to figure out how the STAPLE operational system would work. The plans were detailed to the point where I drew materials and listed the costs next to them, "Squeegees, $10," "Drying Time, 30 mins," "Apply hang tags, 1–2 hours," etc. I mapped out how long it would take me to complete each and every step in the process.

I literally jolted back and reacted with a confused, "What did you call me?"

After the call from Gorie in Japan, though, it immediately hit me — how the hell was I going to break into school with a thousand T-shirts?? And at my damage rate, I might have to print two thousand T-shirts to get one thousand perfect ones. This was a major crossroads moment for me. I needed to streamline my supply chain, which meant no more breaking into school to fucking make shirts. I needed to take a step back and investigate how to make this happen. I didn't know anything about screen printing factories or manufacturing. Google and Alibaba couldn't help with this yet, so it was an incredibly daunting task.

My other option was to rip up the order and forget this pipe dream. However, canceling the order meant canceling everything I had built. It meant killing off "Jeff Staple." What was the point of all this if I didn't take the biggest order I had received? I was so focused on STAPLE that I was doing terribly in school. If I canceled the order, I could focus more on school or maybe even drop out and take a full-time job at C.I.T.E. Design, a design company I worked for at the time. They offered me $50,000 per year if I quit school and worked for them full-time, which was CRAZY money for me.

My Chinese immigrant parents were pressuring me to do the right thing. They wanted me to stay in school, get good grades, graduate, and get a reliable job — not hustle T-shirts by breaking into my school and turning my apartment into a warehouse. It didn't seem like I had an end game with STAPLE to anyone looking in on my situation. My life looked very chaotic. I had already dropped out of NYU with nothing to show for it. Now, I was considering leaving art school to make T-shirts for some dude in Japan I had never met before. Well, spoiler alert: I chose STAPLE.

I called Gorie back and explained my situation. He ended up giving me a 50% deposit so I could fulfill the order. He would then come to New York to pick up the shirts and pay the rest. I quit Parsons after that conversation.

My mom was mortified. She came to the U.S. to have one child who would finish high school, graduate college, become an accountant or lawyer, and buy a BMW one day. But now, her only child was a two-time college dropout who was making T-shirts at school and selling them to five fucking little skate shops. She thought I had lost my mind. Honestly, telling her I was in jail might have been easier for her to process.

I told myself that Parsons would always be there. If STAPLE didn't work out, I could go back to school. I started looking through the yellow pages to find a silk screener who would accept my order. I found a printer in Miami and a printer in New York. The printer in Miami was cheaper by a few cents, so I went with that option.

As luck would have it, the day that one thousand shirts were getting delivered to my apartment was the same day that Gorie was coming to New York to pick them up. It was literally shirts in, shirts out, pay me the money—DONE. When the shirts came in that morning, I opened the boxes only to discover that ALL one thousand shirts were printed incorrectly!!!

It was because I didn't fully understand the manufacturing process yet. The shirt I printed had a front, back, and sleeve design. To save money, I put all the artwork on one screen, and I gave instructions on where to print each design. But the printer put everything on the front of the shirt. It was a disaster. In retrospect, I should have used the New York printer because it would have been easier to communicate what I wanted.

When Gorie showed up to get the shirts, I was mortified. I felt like I had made the biggest mistake of my life by quitting school. I was immediately in over my head and unprepared. I felt terrible, but he was so kind. He decided to stick around in New York until the new order was complete. So I redid the order with the New York printer I found, and it came out perfect the second time around.

So within one year, STAPLE was already being sold in New York City and Tokyo. Most brands work years toward becoming a "global brand," but I had accomplished it in one year because of strategic planning and some luck. What more could a start-up ask for? And guess what? I never ended up going back to Parsons, but I did eventually get an honorary degree. Momma dukes is pretty proud, to say the least.

Sketchbooks · ORIGIN STORY

42

ORIGIN STORY

43

SKETCHBOOKS — ORIGIN STORY

44

Typography

Origin Story

46

ORIGIN STORY

47

Graphic Design · ORIGIN STORY · 48

ORIGIN STORY

49

The Birth of STAPLE | ORIGIN STORY

WHAT ABOUT THE IDEA OF NAMING

ORIGIN STORY

THE BRAND SOMETHING LIKE "STAPLE"?

Now that I knew I wanted to express my thoughts via fashion, I needed to work out the process of what that would look like. These sketches represent the early rudimentary plans of how STAPLE would operate. For example, here, I break down the process of how to actually make a t-shirt by hand.

Early STAPLE logo attempts. Funny story here: I had an idea early on that the STAPLE logo was going to be like a bowl of rice with the thinking that rice is a "STAPLE" food for many cultures. Thank god I didn't go with that! From there I conceived this idea of a dragon coming off the "S" in STAPLE. The S-Dragon image was the logo for a little bit of time before it eventually became the infamous pigeon.

☆ — STAPLE CAMO HOODED
 (CAMO-01)
 - STEELE GRAY
 - ARMY GRN
 - BURNT ORANGE
 — CAMO EMBROIDERY w/
 MATCH COLOR STAPLE LOGO

"WOVEN LABEL"

* VCC?
* LEE X-GRAIN
 (CHECK FRUIT)

ORIGIN STORY

55

gUliaNITimE

$$\begin{array}{r}20\\ \times\ 15\\\hline 100\\ 200\\\hline 300\end{array}$$

4.70 (15,000

20$ - per 1000 stitches.

★ UNITE CREW ③⓪⓪
(UTE-02)
- NAVY / GOLD / GRAY
- NATURAL / MAROON / BROWN
- SILKSCREEN

$$\begin{array}{r}20\\ 11\\\hline 0\end{array}$$

20
14

— LABEL

UNITE

★ LEE X-GRAIN
△ FRUIT

ORIGIN STORY

57

On August 9, 1997, police officers took Haitian immigrant Abner Louima — after yanking his pants down to his knees — in the bathroom of the 70th Precinct in Brooklyn. There, Officer Justin Volpe used a wooden stick to sexually assault the handcuffed Louima. Word of the attack shocked the city, and Louima would eventually testify in a federal trial that sent two officers to prison. In 1997, when news spread of this, the cops were alleged to say, "This isn't Mayor Dinkins Time. This is Giuliani Time."

This era in the city was so heated, I felt like all people or color needed a rallying cry. We needed a secret message to show we were all in this together. "UNITE" was my answer. But inside the word "UNITE" was a hidden message. The phrase "Giuliani Time" is actually embedded inside the same letters as UNITE. The back of the shirt shows a police baton with the words "YOUR TAX DOLLARS AT WORK" under it. I also made the colors match the ones on the NYPD badge. To me, this was the true power of the T-shirt and street fashion. It was graphic design and fashion design hijacked in the name of political awareness and unification.

1/28/96

Well I've gotten a few different inputs about what I should. Unfortunately, no one really understands the situation completely. I've just applied to the 9 jobs on the previous page + I'll see what happens. Here's a new philosophy I have on life & people. There are 3 kinds of people on this planet. ① People who always fail. These people, no matter how hard they try - they fail. Their whole life is met w/ adversity + they can never escape it. These people can be very resilient or they can be lazy; either way; they fail. ② People who neither fail nor succeed. These people maintain + survive. They don't envy people who have success mainly because they are lazy + they are content in the fact that they are a type ①. person. Finally, there is type ③. These people are the ones you hate. The ones who have all they have to be that luck + fortune. They don't even get out of a predic- have to be successful. They just always seem to -ament. Things always work out for these people. It's not really a matter of diligence or laziness; they're just lucky. I am typically a type ③ person sometimes verging on an upper ②. I always thought in high school that a BA degree was definite. Masters? PhD? Yeah- I can't believe in 20 yrs. old + I'm over 3 yrs. away from a BA. What the hell is my problem! And now that I can't go to school anymore - who knows when or ever even!

Well - here's the order of operations: ① Hopefully get a response from a job. ② Take job ③ Tell mom situation - see what she says ④ Either withdraw from school + take job or ⑤ stay in school + rob a bank + win the lottery.

1/28/96

Well, I've gotten a few different inputs about what I should do. Unfortunately, no one really understands the situation completely. I just applied to the 9 jobs on the previous page, and I'll see what happens. Here's a new philosophy on life and people. There are 3 kinds of people on this planet. ① People who always fail. These people, no matter how hard they try — they fail. Their whole life is met with adversity and they can never escape it. These people can be very resilient or they can be lazy. Either way, they fail. ② People who never fail nor succeed. These people maintain and survive. They don't envy people who have success, mainly because they are lazy and they are content in the fact that they are [not] a type ① person. Finally, there is type ③. These people are the ones you hate. The ones who have all the luck and fortune. They don't even have to be that successful. They just always seem to get out of a predicament. Things always work out for these people. It's not really a matter of diligence or laziness. They're just lucky. I am typically a type ③ person, sometimes verging on an upper ②. I always thought in high school that a BA degree was definite. Masters? PhD? Yeah. I can't believe I'm 20 yrs old and I'm over three years away from a BA. What the hell is my problem! And now that I can't go to school anymore, who knows when or ever even! Well, here's the order of operations. ① Hopefully get a response from a job. ② Take job. ③ Tell mom situation. See what she says. ④ Either withdraw from school and take job or ⑤ Stay in school and rob a bank and win the lottery.*

*These were the thoughts of a very angry and resentful 20-year-old struggling to figure life out. Through many hours of therapy, I no longer subscribe to this way of thinking.

JOURNAL ENTRIES — ORIGIN STORY

I believe in fate. People in life follow paths. These paths can be changed but they definitely lead somewhere. And wherever it leads to — that's where you going — like it or not. I'm on a path. I know it. The strange occurrences that have happened in the last ten years have convinced me that I am on path. I'm not sure where but maybe you can tell me.

In 1993. I was a freshman @ NYU. I was pretty sure about what direction I was going in. Probably a career in journalism. In order to get me by financially, I began looking for a pt job. After much searching — and much frustration — I finally found my first job. A was a receptionist position @ a fancy Japanese hair salon in midtown. The pay was pretty great & the people were nice. But busting a suit & tie everyday wasn't my style.

② I don't want a repeat of PNB. I didn't have to be "intern" @ PNB to learn what I did. All I needed to do was hang out there. But on the other hand if they're paying me good when in hell!

③ I don't wanna get a big head but I should try reach higher! He looked at Nike & Shape & he was out cold. I wanna get respected. I wanna price me high. He can say me good that is a good job & good location but what if I can get more & I don't. That sucks. I gotta interview more.

I THINK I'M COMING TO THE CONCLUSION THAT SCOTT IS DEF. OUT. C.I.T.E. IS SAFETY NOW. I'M GONNA INTERVIEW W/ THE OTHER 3 + GET PAID. I'M GONNA BE MAD DEMANDING TOO. ACCEPT NOTHING LESS THAN $12.00/HR. (Remember this!)

I believe in fate. People in life follow paths. These paths can be changed, but they definitely lead somewhere. And wherever it leads to — that's where you're going — like it or not. I'm on a path. I know it. The strange occurrences that have happened in the last year have confirmed in me that I am on a path. I'm unsure where, but maybe you can tell me.

In 1993, I was a freshman at NYU. I was pretty sure about what direction I was going in. Probably business or journalism. In order to get by financially, I began looking for a [part-time] job. After much searching and much frustration, I finally found my first job. It was a receptionist position at a Japanese hair salon in Midtown. The pay was pretty great and the people were nice. But hustling a suit and tie every day wasn't my style.

② I don't want a repeat of PNB. I didn't have to be "intern" of PNB to learn what I did. All I needed to do was hang out there. But on the other hand, if they're paying me good, what the hell!

③ I don't want to get a big head but I should [definitely] reach higher! He worked at Nike and STAPLE and he was out cold. I wanna get rejected. I wanna reach new [highs]. He can pay me good and it's a good location but what if I can get more and I don't. That sucks, I gotta interview more.

I think I'm coming to the conclusion that Scott is definitely out. [C.I.T.E. Design] is safety now. I'm gonna interview with the other three and see plans. I'm gonna be mad demanding too. Accept NOTHING less than $12/hr (remember tax!).*

*Now I realize how arrogant this sounds. This is the entitled stupidity of youth talking. After all, how would I be able to just "hang out" at PNB Nation if I wasn't contributing or interning? Just for context, "Scott" is a reference to my previous job at Noble Desktop Publishers. C.I.T.E. Design was an interior design firm. So I was teetering between two jobs while interviewing at a few others. The takeaway from this entry is the amount of stress and anxiety that was running through me over receiving $12.00/hr. Kanye West said it best: "Money isn't everything. But not having it IS." I did learn about "gross" (pre-tax) and "net" (post-tax) earnings here, though!

Artifacts & Ephemera ORIGIN STORY

62

I was always inspired by political acts of oppression and rebellion.

Note these early business cards with only a landline telephone number on them. No email address. No mobile phone number.

Magazines like The FADER and VICE were so supportive of STAPLE. When they had extra ad space, they would offer me ad pages for like $200. After doing some really interesting advertisements for a few years, a gallery in Hong Kong reached out about doing a retrospective of STAPLE ads. The show was called PUBLIC RELATIONS.

ORIGIN STORY

LEFT: Early STAPLE logo ideas.

ABOVE: STAPLE's 5th Anniverary event in Tokyo, Japan, at Club Harlem.

63

Early on, I managed to score a photo shoot with Yasiin Bey, aka Mos Def. This was literally shot in the elevator of Rawkus Records. I needed to pull off something timeless, quick and cheap. Shout-out to photographer Atsuko Tanaka for capturing this magic moment.

ORIGIN STORY

silkscreens

64

Some of the earliest silkscreens used to print STAPLE tees. Some of these screens were handmade by my own two hands. Each shirt was printed after-hours in school against all rules and regulations. Better to ask for forgiveness than for permission.

ORIGIN STORY

65

> Equifax FACT Act — 10/11/2005 02:35 AM
>
> **Your FICO® Credit Score**
>
> 10/11/05
> **669**
> Poor
>
> - Your FICO score of **669** summarizes the information on your Equifax Credit File as of **October 11, 2005**.
> - FICO scores range between **300** and **850**.
> - The FICO® score is the credit score used most often by lenders. However, the credit file and credit scoring model used by some lenders may be different.
>
> **Key Factors Affecting Your Score**
>
> - Evidence of being seriously late or having derogatory indicators/remarks on your credit obligations is being reported on your credit file
> - The proportion of balances to credit limits (high credit) on your revolving/charge accounts is too high
> - There is evidence of multiple accounts with missing payments or having derogatory indicators/remarks reported
> - You have recently been seeking credit or other services, as reflected by the number of inquiries posted on your credit file in the last 12 months
>
> Your credit score often determines the credit you receive - both the size of the loan you qualify for and the rate you receive. To check your credit score go to www.equifax.com to get Score Power® - your Equifax Credit Report™ and FICO® credit score - online in seconds.
> Or you may obtain a printed version of your FICO® credit score through our automated system at 1-877-SCORE-11. (sent to you via US Mail).
> The FICO® credit score is developed by Fair Isaac. You may contact Fair Isaac by mail at:
> Fair Isaac Corporation
> PO Box 8428
> Emeryville 94662
> www.fairisaac.com
>
> Equifax offers you personal credit products that enlighten, enable and empower you. Whether you are managing your credit, protecting your identity or preparing for a major purchase, Equifax offers the tools you need to make the smartest choices possible. For more information visit www.Equifax.com.
>
> Back to Top
>
> Page 20 of 20

My "poor" credit rating goes to show that starting your own business isn't easy — it can actually ruin you. Even five-plus years into the brand, I was still crazy in debt, maxing out credit cards, and dealing with student loans from a school that I didn't even graduate from. STAPLE wasn't an overnight success story — I was still a fuck-up to my parents — and to my bank account.

ORIGIN STORY

I have always been really bad at math, especially accounting. But I had to figure out a way to keep track of all the STAPLE orders. Orders are great, but if invoices aren't paid, you'll go out of business quick. If I hadn't organized STAPLE like this, I wouldn't be around today. It wasn't pretty, but it was effective.

ORIGIN STORY

The First Catalog

68

This was the first ever STAPLE catalog. It was a tabloid photocopied page on kraft paper that I hand-folded, accordion style. These were the early designs that Triple Five Soul and Union bought. They were very political, in-your-face, and angry. I was attempting to use the medium of a T-shirt to express and acknowledge my problem with injustices in the culture and the world.

ORIGIN STORY

69

Funny story: At one point, after dropping out of Parsons, I got a night job (the 9 p.m. — 3 a.m. shift) at a copy shop ... something like a Kinko's ... but it was called WOW Digital. I pretty much got the job JUST so I could make free copies of whatever I needed for STAPLE. One night while I was working, Brent Rollins — a legendary graphic designer walks in to drop off a job and I am floored and absolutely honored to be in his presence! Fast-forward 25 years later, guess who's the art director of this book in your hands? That's right ... Mr. Brent Rollins!

ORIGIN STORY

1 Sponsoring early rap battles and turntable competitions. I remember making this huge STAPLE banner was one of my first big investments. And I remember needing to hang these by hand myself!

2 "Saikoh! Saturdays" at SWIM, my weekly DJ residency in the Lower East Side.

3 Passed out from the hustle....

4 An early STAPLE sticker.

5 DJ Kuttin Kandy of the 5th Platoon rocking the Major League Footwork Bobbito Garcia hoodie during a battle. One of the first asian female DJs in the game!

6 My early days of interning at PNB Nation.

7 Technics 1200 turntables. A STAPLE of the culture.

8 My one room studio apartment in Chinatown NYC where I lived and where every STAPLE order was made and packed. This photo was taken six months after my first order from Triple Five Soul was placed.

9 Me and Omar Quiambao, who would eventually go on to create the Commonwealth retail empire.

10 Kelly from Hi-Post was my barber. A one-of-a-kind barbershop, streetwear clothing store located in Alphabet City.

11 More of the legendary 5th Platoon rockin' STAPLE.

12 This is Groove Theory's lead singer, Amel Larrieux, repping STAPLE in Japan. One of the best to ever do it.

13 More shots of my one-room studio apartment in Chinatown, NYC.

14 Words from Malcolm X represented the anger in me. I always thought about how I could use my platform to bring awareness to these issues, which was a huge part of my inspiration.

15 With Hong Kong's first rap crew, LMF (LazyMuthaFuckers). It was crazy that the gamble I took to quit school and pursue this little brand literally took me all over the world!

16 Camella Ehlke, the founder of Triple Five Soul, was hugely instrumental in helping me start STAPLE. She gave me free space in her booth at the MAGIC trade show in Las Vegas, which allowed me to get orders from all over the country.

17 STAPLE eventually got its own little 10' x 10' booth, finally graduating from our corner at Triple Five Soul's booth.

18 Sneaker culture circa 1995!

19 At McDonald's. The Dollar Menu fed me throughout the early years. (Didn't do great for my health though!). STAPLE S-Dragon logo on the tee.

20 Me with hair. And wearing a PNB Nation Stretch Armstrong & Bobbito tee. And using a coin-operated pay phone!

21 MC Yan in the midst of a piece on my gate at my first storefront office, at 134 Division Street.

22 Selfie (pre-iPhone).

23 My studio apartment in Chinatown that doubled as the first office and shipping warehouse for STAPLE.

24 Always trying to get STAPLE on the right people. A B-Boy finalist at a Rocksteady Crew battle.

25 Talib Kweli performing at The Violet Cafe at NYU. Of course, this is now a Starbucks.

26 One of many iterations of the STAPLE Bar Logo sticker.

27 This used to be a gas station and auto repair shop at the corner of Houston and Lafayette. Triple Five and STAPLE did this dope two-way collaborative street campaign.

28 Another flyer for my DJ gigs at SWIM.

29 My first trip to Japan for STAPLE. Harajuku's infamous Cat Street.

30 The Chinatown studio with my friend Jean who helped pack and ship orders along with my dog poo-poo (RIP).

31 Jean is also a great artist and designer. She tagged this STAPLE logo on a Post-it that I made stickers and tees out of. I've paid her back in dinners for the past 25 years lol.

34 The 5th Platoon was one of the dopest DJ crews, and they were all Asians. DJ Neil Armstrong was the head of the crew, seen here wearing a T-shirt with a 5th Platoon logo I designed for them and a STAPLE S-Dragon logo hat.

33 Family photo with me rocking an early STAPLE shirt I hand-printed at school.

32 Going to the MAGIC trade show in Las Vegas was cool because I got to meet the people behind other brands just like mine — small start-ups just trying to figure shit out. Charizmatik, BM Basement, Social Studies, and more.... Good old dayz.

ORIGIN STORY

71

ORIGIN STORY

<u>134 Division Street, New York City</u>. *My first storefront office, that would define what STAPLE was to become. This office sat on top of a brothel. Every time the power went out I would have to go into the basement and flip a breaker switch while a lot of moaning and groaning was happening. Gross! Also, whenever I worked late, I would hear rats running around the ceiling panels just above my head. The 9/11 tragedy would eventually force us to vacate this office which then led me to open REED SPACE.*

STAPLE COMMUNICATING THROUGH FASHION

STAPLE COMMUNICATING THROUGH FASHION

74

Fall/Winter 1999
"Complex(city):Simpli(city)"

Collection Two: 1997
6° of Separation/Connection

Collection Two: 1997
Miniature design mock-up of catalog

Collection One: 1997
"Never Forget"
Modeled by Mr. Len of Company Flow

Collection Two: 1997
Modeled by Scott Sasso of 10 Deep
Clothing. (The days when one
clothing brand founder would
model for another brand!)

giUliaNI TimE *Nautical Script*

STPL University Torch *Jean's Tag* *TAKI 183*

C.R.E.A.M. *X-Ray of a GOAT*

One of the reasons I started STAPLE was that I was fascinated by the idea that a simple cotton T-shirt could be a medium for communicating ideas. Even if you choose to wear a blank one, you are invariably saying something about yourself. From the early years to the formative years to current day, I always tried to adjust the needle of "provoking thought" and "commercial viability." The RZA once told me, *"Every album needs a club banger. Then once you lure them into your world, you gotta teach the math."* I learned that in design, sometimes you can be fun and playful. And other times, it is necessary to speak volumes.

STAPLE COMMUNICATING THROUGH FASHION

82

Throughout the decades, I've been amazed at how the Pigeon could be utilized in different size scales and techniques. From half-inch embroideries to all-over prints. From video games to origami to a blank canvas for other creatives to express themselves on. This most-hated villain has truly become the unofficial mascot of not only New York City, but any urban dweller worldwide. One of the greatest compliments I ever received was this: *"Jeff did for the Pigeon what Walt Disney did for the rat."*

STAPLE COMMUNICATING THROUGH FASHION

83

I knew the move into cut-and-sewn pieces was always a goal for the brand. You have to understand, I broke into art school just to hand-print tees! I had no proper fashion background whatsoever. So just the idea of making a jacket was crazy. After many many trial-and-error years, I was finally able to make some pieces. These are some highlights for me. A technical waterproof jacket made in Japan. A proper melton wool, leather-sleeve letterman jacket. And another letterman jacket created in collaboration with legenday military supplier Rothco as well as old-school footwear brand PONY.

STAPLE COMMUNICATING THROUGH FASHION

85

Creating a clothing collection is not just about making apparel. There are labels, hangtags, pins, stickers, event coordination, invitations to events, flyers, etc. These are all elements that add to the narrative of a clothing collection. The sketch on page 87 is a note to me from legendary skate god Harry Jumanji. Inspiration can be seen from all around. You just have to be open to looking.

P.S. I'M FREE & HEALTHY) SEPT. 24TH 2008

YO, → "Jeffrey," WHAT'S REALLY GOOD MA+ ASIAN-BROTHA PROM-ANOTHER....

100% ∞
SKATEBOARDING SAVED MY LIFE,

& "Life is Good" (IF YOU ALLOW-TO BE, & BE GOOD TO YOURSELF & OTHERS)!

THINGS ARE "A LOT" BETTER NOW KID, & CAME BY TO SAY HELLO "BUT UNFORTUNATELY ONCE AGAIN YOU AINT HERE".. 🐱 WELL, WE WILL SEE EACHOTHER SOON KID!!! (I HOPE)

(GOOD NEWS, NO MORE PAROLE,)
& ALSO GOT A FILM/DOCU COMING OUT—

"I Love you, & got mad Respect for you YOU ALREADY KNOW THAT Always!"
⭐⭐⭐⭐⭐⭐⭐

"HAPPY O.G. JUMONJI * 100% SKATEBOARDER SINCE 1978"
PLEASE CALL ME (917) ███-████ PEACE

NEW YORK TIMES SHOT MY SKATEBOARD) TWO DAYS FRESH OUT OF LOCKDOWN (NOT SAD)

STAPLE COMMUNICATING THROUGH FASHION

87

STAPLE COMMUNICATING THROUGH FASHION

88

Spring, 2002

Spring, 2007

Fall, 2008

Catalogs are another extremely important design element for a clothing collection. Before there was any budget to make a proper catalog, I had to do it by any means necessary. Spring/summer 2002 was your basic color copy print-out, bound at a Kinko's and featuring my own photos. Spring 2007 was photographs simply bundled and wrapped in fabric used for the actual clothes that season. Fall 2008's collection was inspired by messengers and santiation workers. Each catalog was hand-crafted by me using scraps of cardboard, packing tape and custom name stickers.

STAPLE Spring, 2003
"A Day in the Life"

STPL Spring, 2010
"Econ+Major"

STAPLE Fall, 2006
"Horror"

As STAPLE progressed, so too did the production of the catalogs. At this point, I decided to split the line into two sections for each season. STAPLE was to stay true to its roots of T-shirts, imprintables, and graphic design. STPL would advance into areas of cut-and-sew and fashion design that I was interested in experimenting with. The price points were vastly different, so the points of distribution would be as well (before e-commerce days still). Hence the need for two separate catalogs each season.

STPL Spring, 2006
"Chinatown"

STPL Spring, 2008
"The Science of Life"

STAPLE Fall, 2005
"Life Is a Gamble"

STAPLE Fall, 2008
"The Science of Life"

STAPLE Spring, 2010
"Econ+Major"

STAPLE COMMUNICATING THROUGH FASHION

92

STAPLE Fall, 2007
The 10th Anniversary Collection, creative-directed and designed
by Brendon Babenzien of Supreme and Noah.

STAPLE Spring, 2007
The 10th Anniversary Collection, creative-directed and photographed
by Yasumasa Yonehara.

STAPLE.COM COMMUNICATING THROUGH FASHION

I started to introduce more mature sophisticated styles like button-down shirts in both long - and-short sleeve varieties. I'm most proud of the one on left, utilizing fabrics from the legedary London department store, Liberty of London. This fabric was also translated onto a pair of Oakley Frogskins which was unprecedented—even today.

Details, details, details.
From the corduroy fabrication, to the main label, to the detailed all-over embroidery of our flying Pigeon, to custom-made buttons, to the minutiae of details in the placket label. Everything matters.

The Art Start Project is one that I am most proud of. STAPLE has rarely collaborated with other streetwear brands in the same industry. But this idea I had was too good to not explore. What if two east coast brands and two west coast brands came together to help young people in need? That's where 10 Deep, HUF, Black Scale, and STAPLE came together to create a collection that donated all proceeds to the nonprofit organzation Art Start. The words on the chest reads "The Youth Shall Inherit the Earth."

STAPLE for Levi's & Google's Project Jacquard, 2018

STAPLE COMMUNICATING THROUGH FASHION

99

STAPLE COMMUNICATING THROUGH FASHION

Various STAPLE head wear pieces from past collections made in conjunction with New Era, 47 Brand, Starter Black Label, Liberty of London as well as in-house.

STAPLE COMMUNICATING THROUGH FASHION

101

STAPLE COMMUNICATING THROUGH FASHION

102

Various STAPLE hooded sweatshirts from past collections made in conjunction with Karl Kani, Timberland, MTV Networks, and Sabotage as well as in-house.

STAPLE COMMUNICATING THROUGH FASHION

103

STAPLE COMMUNICATING THROUGH FASHION

104

In 25 years of developing STAPLE, this is one of my favorite pieces of all time. I don't say this lightly. Achieving a near-perfect piece is an almost impossible goal that I strive for each and every season. Honestly speaking, it happens rarely. (Or maybe my standards are too high?) This involves trying to balance a symphony of fabric, color, wash, concept, graphics, type, application, fit, and durability.

STAPLE x Sabotage

يفلدوجي

ISSUE: STAPLE + SABOTAGE
FROM: NYC TO SIN

يفلوجي

STAPLE x Casio G-Shock

STAPLE x Liz Beecroft / Mentl Sesh

STAPLE x Hello Kitty

STAPLE x Atmos

STAPLE x Allbirds

STAPLE x Ageless Galaxy

STAPLE x NY Forever

STAPLE x NTWRK

STAPLE x Christina Paik

STAPLE COMMUNICATING THROUGH FASHION

107

"I've known about Jeff and STAPLE since the beginning. As Asian Americans out here in this world, we don't have many people affecting culture in the public eye. So when one of us is out there doin' it, you bet we all know. But I didn't meet Jeff until way later, in a random momentary occurrence in front of the Kogi truck at ComplexCon in Long Beach, California. It was a sunny, crisp day in the LA winter, and Jeff was wearing futuristic Oakley sunglasses and some crazy-ass shoes. I gave him some tacos, and we instantly became friends.

After that first encounter with Jeff, we became friends from the jump—talking, texting, DM-ing, whatever. At Best Friend, we have a liquor store in the front where we sell shit. It was a fluid, creative conversation to pull the three cities we both love all together in a collab around Best Friend. NYC to LA to Vegas. Best friends.

He's a visionary. Leader. Hard-worker. Funny. Kind. Connoisseur. Futurist. Thinker. Positive role model. Walker of different worlds. He's like James Bond eatin' dim sum."
—
Roy Choi, chef

STAPLE x Mobb Deep

STAPLE x Roy Choi

STAPLE x Ginnika

STAPLE x Mobb Deep

STAPLE x Shake Shack x Uber Eats

STAPLE x Tag Heuer x Bamford

"It was easily one of the most fun collabs I've ever been part of, as this was the first time I worked with an artist who loves food instead of a chef. Jeff brought a different perspective to the collab and talked a lot about how the concrete should look visually first, which was then fun to riff off flavor-wise to make the vision cohesive and delicious.

Jeff was fun and challenging to work with because his vision for the concrete pushed the boundaries of what we create within our Shake Shack menu. Jeff wanted to create a concrete—frozen custard coarsely blended with different mix-ins, such as salted caramel sauce, chocolate brownie, fruit, or pretty much anything that would taste delicious—inspired by a pigeon. He said, "A pigeon is most often gray in color and has little red feet. I want the concrete to look like that." My first thought was, "Yuck. Gray is not the most appetizing color. There aren't a lot of delicious gray foods that come to mind, and that part about the pigeon feet..." What we came up with was a vanilla frozen custard blended with a black-sesame-glazed cake doughnut, which represented the gray pigeon, and raspberry jam for the red feet. It was a wild idea, but coupling the idea of a pigeon with something craveable and old-fashioned like a jelly doughnut, but deconstructed, wound up being both delicious and visually interesting."

Mark Rosati
Culinary Director, Shake Shack

STAPLE COMMUNICATING THROUGH FASHION

110

STAPLE x Spirit Jersey

STAPLE x Snowpeak

STAPLE x Big Crown Records

STAPLE "Publicity" Tee

STAPLE x DesignerCon

STAPLE "Pigeon Architects" Tee

STAPLE X FUTURA
FOR BLACK LIVES MATTER.

Nearly a quarter of a million dollars was raised through this campaign to increase awareness, voice, and assistance to the BLM movement.

"STAPLE … Wow … celebrating its 25th anniversary. I can't believe how quickly time has passed. It has been fantastic to witness a quarter-century of a historic timeline in the making.

One of the most iconic brands from NYC, STAPLE has always had a wonderful aesthetic between design and production. The Pigeon Dunks are amongst the grails of footwear. I also want to thank Jeff for our Black Lives Matter collaboration. And, for the record, time travel is actually possible, as we are living proof!"

FUTURA

I created this shirt on the left in black for myself and for friends and family. It was never made for sale. I wanted to create an homage design I dubbed "The Pigeon Architects." I asked myself who were the people that directly or indirectly shaped who I was as a man, and hence what I would be able to create. The names are listed on the back alphabetically. This shirt basically became my uniform, which I would wear almost everywhere I needed to make a public appearance. Fast-forward a few years and the popular trade-show convention called D-Con (DesignerCon) asked me to collaborate with them. They loved The Pigeon Architect tee and wanted a version where I shout out exhibitors of the trade-show that I had a close tie with. Just goes to show that even when you do things just for fun and not for money, if you put passion, heart, and authenticity behind it, it usually leads there one way or another.

STAPLE COMMUNICATING THROUGH FASHION

112

STAPLE "Nike Navigation Mix" by Bluntheadz

"45ARepm" by DJ Muro

"Lost Mixes Volume 7" by Hiroshi Fujiwara

"The Sessions Volume 1" by DJ Chillout

"The Sessions Volume 4" by DJ Green Lantern

Music is one of my most important points of inspiration. You'll see a running theme of me collaborating with people in music. I do believe that music is the truest art form. A painter or illustrator starts with a pencil and a blank canvas. But a musician starts with nothing. He or she must manifest magic out of thin air. Its unthinkable. While STAPLE never became a full-fledged record label, I did dabble multiple times in creating platforms for musical artists to express themselves, working with some absolute legends in the industry.

The Disk Doctor: Prescription #1 by DJ Soul

The Disk Doctor: Prescription #2 by Ken Sport

The Disk Doctor: Prescription #4 by DJ Drez

"The Sessions Volume 3" by DJ Nickodemus

"Grow" by Spec Boogie

REED COMMUNICATING SPACE THROUGH RETAIL

My crude initial interior sketch of the floor plan and layout for how Reed Space would be organized.

Our previous office was located in the shadow of the World Trade Center. We had front-row seats to the 9/11 tragedy. Needless to say, we needed to find a new home. At the time, I had regular weekly DJ residencies in small bars and clubs in the Lower East Side. Back in thos days, there was no Uber and there was no Serato. This meant that at 4:30am, after my set was done, I was left standing on Orchard Street waiting for a taxi that would take me and my eight crates of records home. Sometimes I'd be there waiting more than 30 minutes on a cold NYC street corner.

On one of these nights, I peered into an empty storefront space with a "For Rent" sign in the window. It was a gorgeous space. It went through the entire city block with entrances on both ends! We needed a new space and I always did dream of having a retail store that could stock STAPLE and my friends' brands. I didn't have the slightest idea of how to actually make this happen, but here I was staring at what would become Reed Space for the next 15 years. The rent for my Division Street studio was $2000/month. This new space was $8000. So it was a 4x increase — the scariest gamble I made in the business up until that point. I rolled the dice, called the number on the sign, and before I knew it, I had the keys in my hand. Now all I had to do was build the dream. And hope people show up.

LACK shelf-new WHITE 3 x 43¼ L. $12.95

p172 HELMER drawer unit $59 RED Lacquered x 5 units

ROLLING RACK

$78 EXPEDIT bookcase $199 WHITE
1 FOR OFFICE
1 FOR APT.

p167 ANTON drawer unit w/ drop-file storage $89 ea. x 2 units

FILE CABINET

FILE CABINET

JEFF

KITCHEN

ACCON.

UP

OFFICE catalog

CONFERENCE

OFFICE catalog p 56, 57 JULES visitor's chair $49 x 4 RED

FILE CABINET FAX ETC. ON THE TOP

meat cutting

p54 SOFA Table WHITE finish $24.95 x 2

From there creating a to-scale rendering, including pricing for each and every piece of IKEA furniture—down to what page number it appeared on in the catalog.

Dustin Ross

Reed Space shopping bag customized by Harry Jumanji

Reed Space's collection of stationery goods, called "reedwrite"

Map of the Lower East Side seen in Reed Space's brand book

Luke Chueh for Cancelled Flight

STAPLE exhibition "Public Relations"

Allister Lee

Kenji Hirata

Code;C

Graniph's first U.S. exhibition

HunterGatherer for Nike launch

Yonehara Yasumasa

Sen Jarnot

Nike Considered launch

Diamonds & Pearls
New Works By Mr. Florencio Zavala

Florencio Zavala

Cody Hudson

Classic Material book launch

Greg Lamarche

Like Lipstick Traces exhibition

Little-known fact: Reed Space is named after my high school art teacher — Michael Reed. Mr. Reed was the most influential person in my life up to that point. He not only taught me about art, but about the importance of mentorship. He taught me the power of the words "Yes, I can help." He passed away in my senior year in high school and it was devastating to me. From that point on, I dedicated my entire pursuit in the creative arts to him. Every sketchbook was for Mr. Reed. For every computer I owned, the hard drive was name Mr. Reed. And when it came time to named the store — it was a no-brainer. This wasn't my space, it was his space. It was Reed Space. So I knew even before I signed the lease that one of the pillars of Reed Space would be art exhibitions.

REED SPACE COMMUNICATING THROUGH RETAIL

124

The friends and family of Reed Space

Reed Space Japan

Reed Space Singapore

Reed Space at Lane Crawford Hong Kong

Reed Space Honolulu

Reed Space at PacSun

The success of Reed Space in the Lower East Side allowed for many expansion opportunities. I remember in the first year that we opened, people would walk into the space and they would have absolutely no idea what we were. They would literally ask, "What is this place??" So I was joyfully redeemed when various partners and friends around the world asked if they could try to re-create the soul of Reed Space in their own home towns. The most ambitious effort was Reed Space Japan. Sitting in the heart of Aoyama, the Tokyo satellite was everything people loved about the LES location — on steroids.

Soon after, spaces opened up in Singapore, Hong Kong at Lane Crawford, and in Honolulu. This was so mind-blowing to me. Reed Space was a place I stumbled into as a reaction to the 9/11 tragedy. I named the space after my late high school art teacher. And now Reed Spaces were popping up everywhere! It was so surreal to be able to spread the good will of what we created in the humble Lower East Side all over the world.

The most interesting expansion was our partnership with Pacific Sunwear "aka PacSun". PacSun is a mall-based retail outlet with thousands of locations spread all across America. We started a conversation about what it would look like to bring the culture of Reed Space into cities all over the country. With street culture and sneaker culture exploding, it only made sense that the timing was right. But in order to do this, we had to get the blessing of all the brands that we stocked. After all, it wasn't our call to make if these brands wanted to be sold at your local mall. I remember organizing an epic brunch at Soho House in the Meatpacking District where it was literally a who's who of the elite. Every brand owner of every brand we stocked showed up and we had a roundtable discussion presenting this idea of Reed Space at PacSun. The support and response on all sides was overwhelmingly positive and we were green-lit! The rest is history….

Reed Space even expanded within New York City. Right next door to Reed Space was a space opening up and I decided to take it and form a new concept called Reed Annex. On its surface, Reed Annex would be a space where we would sell the previous season's stock on sale in order to leave the main Reed Space fresh and at full price at all times. Reed Annex also provided a space where we could host workshops and talks without disrupting the sales floor of Reed Space. The concept behind the design of the space was that you were situated in the warehouse of Reed Space. So one of the coolest elements of Reed Annex was the fact that the entire space was outfitted using shipping supplies and custom-fabricated furniture created by interior designer Sinclair Scott Smith.

Some of my favorite design elements:

- Shipping pallets that doubled as sliding drawers for storage.

- Peg Board wall to display clothing facing out.

- Cash Wrap Counter constructed using only ULINE shipping tubes and a piece of tempered glass.

- Empty cardboard boxes with vinyl graphics that were used as point-of-purchase displays.

- Industrial nautical-style overhead lights.

- Custom-made storage cubes that could be stacked and used as seating.

- A conveyor belt — normally used for transporting boxes — repurposed as a sneaker display rack.

REED SPACE COMMUNICATING THROUGH RETAIL

130

Jose Parla for Reed Pages

Erykah Badu for Reed Pages

Mister Cartoon for Reed Pages

Interior spreads and business cards

REED SPACE COMMUNICATING THROUGH RETAIL

131

Reed Pages was our first foray into print publication. We only published two issues but those two books really created a shockwave of influence throughout the entire industry. The concept was dead simple. Each issue would consist of an A–Z format with one feature per letter. This way, the flow of the magazine would be completely diplomatic. There was no "big feature" or "small piece." All the stories carried equal weight because we organized it alphabetically. We also revolutionized advertising. I was inspired by public television shows like "The Joy of Painting" with Bob Ross. I noticed that those shows had no commercials. Instead, at the end of each episode, an announcer would say, "This episode was made possible by support from [XXX] groups and foundations." I thought, why couldn't we do this for magazines? So I offered supporters two options: black page or white page. Then the logo was placed in a 2″ square in the middle with a thank you statement at the bottom of the page. That was it. John Jay, executive creative director of ad agency Wieden+Kennedy proclaimed, "If this idea catches on, we are in big trouble!"

After 15 years in the same location, Reed Space finally closed its doors in 2016. I kept the company and trademark of "Reed" alive because... I dunno... I just felt like there was another chapter ahead for it. A few years later, my team at Staple Design Studio (the creative agency arm) decided it was time to rebrand the agency with a new name. Both the clothing line (STAPLE) and the creative agency were gaining popularity and the confusion was frankly getting annoying.

It wasn't even my idea, but the team suggested that we resurrect the "REED" name for the agency and call it the Reed Art Department. I really loved the storyline that RAD was possibly like the "art department" that was really responsible for everything. And in many ways, that is true. The rebrand to RAD allowed that ethos to come front and center. After all, Michael Reed was in fact behind this the whole entire time.

PARTNERSHIPS & COLLABORATIONS

ADIDAS PARTNERSHIPS & COLLABORATIONS

During my tenure as creative director for New York City retail shop Extra Butter, I had the honor of working with adidas on various projects. The EB team and I worked diligently to be recognized as a "consortium" tier shop, which is a shop recognized as best in class. Soon after, we were blessed with the ability to work on special product collaborations.

The Extra Butter founders are of Indian descent, and cricket is massively important to them and their culture. We took adidas's Primeknit technology and fused it with the traditional look of cable-knit sweaters often seen in the game.

Adidas Consortium x Extra Butter SC Premiere Cricket (2020)

Courtesy of Extra Butter

PARTNERSHIPS & COLLABORATIONS

Extra Butter x adidas Alphabounce Beyond "VO2 MAX" (2018)

AIRWALK PARTNERSHIPS & COLLABORATIONS

Airwalk The One by Colette (2017)

When I was a kid trying to skateboard down my driveway in New Jersey, it was all about Variflex decks and Airwalk sneakers. So it was wild, that many decades later, Airwalk reached out to me in 2009 about developing a brand extension exclusively for Payless. I thought it could be really interesting for my brand, known for high-end instant sell-out drops, to potentially have an affordable division of shoes at Payless ($49.99 and under). Authentic Brands Group eventually acquired Airwalk, and we happily extended the collaboration.

—
"The unique thing about Jeff is his unicorn-like ability to balance the fine line between cash and craft. He's able to make sure his projects remain commercial enough, yet at the same time, not forsaking any artistic integrity. He constructs projects of all mediums — digital and physical — in a way that consumers are able to understand the concept right away."

Nick Woodhouse
President of Authentic Brands Group

Airwalk The One by STAPLE (2017)

"Jeff was an early supporter of the first Kickstarter shoes we launched, which were the original genesis of Allbirds. Jeff saw the future around natural materials earlier than anyone else. To go back and reconnect with Jeff many years after he had first posted about our project was special. His iconic "pigeon" was involved, which added to the connection.

Jeff is an incredible storyteller with his pulse on the culture who is willing to take risks creatively. Connecting Allbirds to street culture was a risk, but it paid off and drew enormous energy and interest from both sides of the conversation. Jeff is, more than anything, a connector of ideas."

Tim Brown
Co-Founder of Allbirds

I believe that design and storytelling have the power to change people's perceptions and decisions. Allbirds is a brand everyone knew about, but not everyone rocked—especially in my circles. I often wonder why some brands get a pass and others don't. Allbirds does many incredible things as an independent business, especially their work for the environment, so why wasn't my generation adopting it? The Allbirds STAPLE Dasher aimed to create an organic dialogue between the streetwear community and Allbirds's environmental ethos.

Allbirds STAPLE Dasher (2020)

ALLBIRDS PARTNERSHIPS & COLLABORATIONS

142

Allbirds STAPLE Dasher (2022)

"In 2013, Jeff and his team reached out to Art Start to support our mission with New York City young creatives. They dropped a bomber jacket and snapback cap, and a percentage of funds went to Art Start's youth programs (page 98). The items sold out in one day! It was the first of many opportunities over the years that Jeff saw to position streetwear profits to impact the streets in deeper ways. Jeff always stayed in touch and offered additional support, advice, and encouragement between collaborations. His showroom in Manhattan hosted Art Start youth interested in the fashion and marketing world as visitors and even interns. Recently, his design company Reed Art Department took on the rebrand of Art Start in celebration of our 30th anniversary.

Working with Jeff on collaborations over the years has been different because Jeff sees Art Start youth as artists and creatives with potential, first and foremost. He's passionate about his values and the belief that you don't have to try to be like any successful artist you admire; you can aspire to be the highest level of yourself, which can even surpass that role model. Access to opportunities is a real thing, and Jeff is always trying to add that extra step to every collaboration so that Art Start participants can access more.

Jeff also leverages industry collaborations in ways that make you forget that folks may be competitors. That takes confidence, creativity, and a strong set of values. It's exciting to see different brands work together on dope products, and it pushes us all in the creative arts world to think inclusively and collaboratively."

—
Johanna De Los Santos
Executive Director of Art Start

PARTNERSHIPS & COLLABORATIONS

145

Art Start Rebranding (2020)

ATMOS PARTNERSHIPS & COLLABORATIONS

Atmos x STAPLE x Be@rbrick
"Panda" 100% & 400% Set (2020)

146

—
"When I met Jeff, he was already famous. We did not know each other because I [only] had a small shoe store. However he was really nice, and we talked about shoes. Talking about shoes was a very easy topic to understand for us.

Both the New Balance and Be@rbrick collaborations that we did were very "Jeff." Many customers love his ideas, and every time we collaborated, customers lined up, and the items sold out fast. He is a famous street fashion OG, and everyone respects him. Jeff is always using new methods of selling and technology. He makes modern culture."
—

Hommyo Hidefumi
Founder of Atmos

Atmos x STAPLE x Be@rbrick "OG Pigeon" 100% & 400% Set (2017)

Beats by Dre x STAPLE Collaboration (2012)

PARTNERSHIPS & COLLABORATIONS

149

BURTON
PARTNERSHIPS & COLLABORATIONS

The creative relationship between STAPLE and Burton has been long and fruitful. Our partnership spans more than a decade and across many divisions in the brand including Burton mainline, Gravis, Analog, Ronin, [ak], and iDiom. The leadership Burton provided in snowboarding perfectly paired with my passion for the sport.

I started my relationship with Burton by doing freelance design work for them for over 10 years. It was non-collaborative, just design work for hire. Tangentially, Burton had a sub-line coming out of Japan called iDiom. It was a joint design effort between Hiroki Nakamura of visvim, Hiroshi Fujiwara of fragment design, and Burton. The line added street fashion, sensibility, and style to Burton's highest performance gear, which was called [ak]. It was an extremely successful project.

As visvim became ever-encompassing, Hiroki stepped away from the project. A conversation about it came up while I was on a snowboarding research and development trip with Hiroshi. Greg D. from Burton called up Hiroshi to figure out who would replace Hiroki, and I was in the room during that call. They soon concluded that I would be a good fit to fill those boots. It was really dope when we announced that iDiom was a collaboration between STAPLE and fragment design. It was a big moment because I was a huge fan of the brand.

151

PARTNERSHIPS & COLLABORATIONS

Burton iDiom Collection (2009)

CLARKS PARTNERSHIPS & COLLABORATIONS

152

Clarks x STAPLE Collaboration (2014)
Tawyer Helix, Tawyer Twist, Originals Wallabee

CLOT SOLECIETY BOOK PARTNERSHIPS & COLLABORATIONS

PARTNERSHIPS & COLLABORATIONS

155

Editorial Direction for Soleciety Book Produced by CLOT (2007)

COCA-COLA PARTNERSHIPS & COLLABORATIONS

156

Coca-Cola x STAPLE Collaboration (2019)

COLE HAAN PARTNERSHIPS & COLLABORATIONS

158

Cole Haan x STAPLE 2.ZERØGRAND Stitchlite (2017)

Creative Direction for Hasan Minhaj x Cole Haan Collaboration (2020)

Cole Haan x STAPLE ØriginalGrand Ultra (2020)

"Many Cole Haan devotees grew up in sneaker culture and are inextricably linked with the innovative products we've pioneered in partnership with Jeff and STAPLE. What has always been special about collaborating with Jeff over the last decade is his curiosity. He always arrives with a "what if" spirit and a genuine interest in what we're up to. One of our many meaningful collaborations began during a conversation in our showroom in 2016. Jeff went into full curator mode, ripping through our product collections like a flea market junkie. He conjoined disparate styles and uses into what became our breakout 2.ZERØGRAND Stitchlite™ Oxford collaboration. It's this kind of passion, energy, and vision that Jeff has brought to every project."

Scott Patt
Chief Creative Officer of Cole Haan

CONVERSE PARTNERSHIPS & COLLABORATIONS

160

Converse x STAPLE Sea Star (2008)

CROCS PARTNERSHIPS & COLLABORATIONS

162

Crocs x STAPLE "Sidewalk Luxe" Collaboration (2022)

PARTNERSHIPS & COLLABORATIONS

163

DIME MAGAZINE PARTNERSHIPS & COLLABORATIONS

164

I was the art director and STAPLE Design handled the overall creative direction for *Dime Magazine* from the publication's inception. I even created the prototype issue that they used to get initial funding. My team designed at least the first 50 issues. I was paid a very small amount of money for it, but I believed in the publication's vision and the team, so I took a leap of faith. That decision paid off in a big way because we became creative partners for many years to come.

This relationship was very similar to my days at *The Fader* (page 174).

Sure there were more prominent publications, but the advantage of working for an independent publisher is creative freedom. I could do whatever I wanted, and the *Dime Magazine* team had full faith in my vision. Shout-out to Josh G., Pat C., and Jed B. for that.

This experience taught me an early lesson that I hold with me until this day. Look out for the four F's in a project. Fun, Finance, Freedom, and Folio. Will it be fun to work on? Are you passionate about the project? Will it pay well? Will it offer you creative freedom? Will it be good for your portfolio? If you can say yes to two out of those four, you're probably doing something right.

Dime Magazine was the perfect example of a project that didn't pay well but turned into a long, consistent, fruitful relationship. I think a lot of people might have been like, "Fuck that. I'm not doing it." But then they would have never seen what's on the other side of the rainbow.

Dime Magazine Covers (2001 and beyond)

DR. MARTENS PARTNERSHIPS & COLLABORATIONS

"This project was a while in the making, but we finally managed to bring it to life to celebrate the 20th Anniversary of STAPLE Design. The team and I worked closely with Jeff on the STAPLE 1461 from concept to consumer. Jeff is extremely clear and meticulous with regard to his ideas and plans. Jeff is part of the culture, a storyteller, and one of the originators of streetwear as we know it. Reed Space and the STAPLE brand have been at the forefront of key cultural moments for a minute."

Darren McKoy
Global Director of Footwear
at Dr. Martens

Dr. Martens x STAPLE 1461 Shoe (2017)

EXTRA BUT WORLD

Extra Butter Interior Design in Collaboration with Nobuo Araki/The Archetype (2017)

After Reed Space closed its doors in 2016 I began missing retail curation. It's unique to combine apparel and footwear merchandising, interior design, lighting design, music, scents, and editorial programming into one physical space. It's a bit like creating a theater piece every single day. Extra Butter founders Ankur Amin and Nick Amin realized that a partnership between our two neighborhood boutiques could make us stronger as combined forces. After a fateful breakfast at Russ & Daughters (what could be more LES?), we were off to the races to create greatness together.

The opportunity allowed me to revisit the part of retail I love — high-level creative direction. Thankfully, Ankur and Nick specialize in the part I don't love — administrative details, like inventory control. I got to work on the store's rebranding and overall concept.

The name Extra Butter stems from our mutual love of film and cinema — that moment when you ask for extra butter on your popcorn at the theater. "Butter" is also a phrase used as a compliment in the streetwear space like, "Oh, that's butter. That's dope."

We really leaned into that double meaning.

We opened up the space on both sides so people could enter from Orchard Street and Allen Street, which was very reminiscent of Reed Space. The whole space can convert into a functioning movie theater. A movie theater screen comes down from the ceiling, and a retractable red movie theater curtain covers all the products on the sides. Every night, we close up the curtains and drop the movie theater screen down. As people walk by, they can look inside the store and watch a film playing. Then, every morning, the screen comes up, the curtains open, and the product becomes available again.

To bring this project to life, I called on my friend and mentor, Hiroshi Fujiwara, to help choose an architect and interior designer. Nobuo Araki answered the call to create his first-ever US retail project. After setting the standard with SOPHNET, The POOL Aoyama, The PARK•ING Ginza, Stüssy Japan and others, Araki-san and his team created cinematic magic in the Lower East Side of New York City.

EWING PARTNERSHIPS & COLLABORATIONS

172

Ewing Athletics 33 High x STAPLE (2016)

Johnny Utah (R.I.P.)

PARTNERSHIPS & COLLABORATIONS

173

"When I met Jeff, he was just starting STAPLE. I had just left Arista Records and Bad Boy, where I helped Clive Davis and Puffy build their labels, and I had just started Cornerstone and The Fader. I met with Jeff, and he jumped at the opportunity to design the magazine.

I learned so much about design from Jeff. When he was designing our logo, he explained that letters have their own style. I had never looked at letters as having their own style before. He started showing me how you can play within what a letter is.

I love The Fader logo today, but the iteration he did on day one is special because it's so simple. It wasn't a traditional, huge title across the top like a sports magazine. It was this little understated box that said The Fader. He nailed it — it's only changed three times in 20 years of printing. Even our early merch he designed for us had such layers of complexity to them, and they were so desirable to our audience. He helped define a lane and build a sturdy foundation for The Fader. It was a privilege to have him be part of that."

—
Rob Stone
Co-Founder of The Fader

The Fader Magazine Art Direction (2000 and beyond)

HERSCHEL PARTNERSHIPS & COLLABORATIONS

Herschel x STAPLE Knowmatic Kit (2013)

"In the early days when we were trying to gain momentum, the opportunity to work with Jeff was unbelievable and helped propel our brand further."

Lyndon Cormack
Co-founder of Herschel

"We really wanted Jeff to be the star of our collaboration. We named the collaborative collection of bags the Knowmatic Kit. The bags were specifically built for Jeff to allow him to travel seamlessly. It was a great partnership. We followed him on a trip to Boston for the photo shoot. He was gracious enough to open his home to us, and we shot him in his loft all the way through when he was at the airport and on a plane. It wasn't just about traveling, but rather Jeff's personal approach and how he put himself together."

Jamie Cormack
Co-founder of Herschel

HELLO KITTY PARTNERSHIPS & COLLABORATIONS

184

Hello Kitty x STAPLE Collaboration (2020)

HONDA PARTNERSHIPS & COLLABORATIONS

Honda Ruckus by STAPLE. Produced in conjunction with Cycle World (2014)

HYPEBEAST/BUSINESS OF HYPE
PARTNERSHIPS & COLLABORATIONS

The Esteemed Guests of "The Business of HYPE" on HYPEBEAST (2018)

HYPEBEAST/HBX NEW YORK PARTNERSHIPS & COLLABORATIONS

Interior Renderings of HBX-NYC. Courtesy of Food New York / Dong Ping Wong (2019)

It's fascinating how big things often start really small and simple. The Business of HYPE podcast is the perfect example of that. People used to stop me in public and ask me about sneaker collabs or streetwear, but after Business of HYPE, nine out of ten people only asked me about the podcast — the shift was that drastic.

The show made such an impression on people all over the world. And more often than not, meaningful projects like this start very innocently. Kevin Ma and I were having dinner at Noho Star, and the conversation turned to podcasts. We talked about how it would be cool if we started one. He said, "Let's try three episodes and see how it goes." Before we knew it, we were on our way to 100!

My relationship with HYPEBEAST then blossomed into working on their retail expansion into the U.S. with HBX NYC. We began working on the literal and metaphorical foundations of their new headquarters. Having the opportunity to build the core team, secure brand partnerships, and work with environmental design studio FOOD New York and its Founding Director Dong Ping Wong was amazing. Taking my retail experience from Reed Space and Extra Butter and then combining it with the firepower and influence of HYPEBEAST was a match made in heaven.

"Jeff and I thought it would be cool to have a platform to interview key people of the industry, so we began working on this together, and it became an exciting project. It was great, because he interviewed many insightful characters, and the questions were engaging and inspiring.

I am proud of Jeff's work; he truly is a great host and moderator. He's also really easy to work with, and I can always learn a lot from him. He understands culture inside out and always has so many great ideas and connections. But most importantly, we connect well with each other, and I enjoy his company, which makes it exciting to work with him."

Kevin Ma
Founder of HYPEBEAST

JAMES JEAN — PARTNERSHIPS & COLLABORATIONS

"Jeff approached me to create something to celebrate the 20th anniversary of STAPLE. I had never made a statue or figure before, so this project broke new ground for me. Working with Jeff on the WASHIZU project was easy and smooth — like his head! I had complete freedom to do what I wanted, and he executed the release very quickly and efficiently.

It's incredibly hard and time-consuming to create a sculptural edition at a high level, but it took a spark from Jeff for me to actually pursue it. I produce many sculptural editions these days, and it's very cool to say that WASHIZU kicked it all off."

James Jean
Artist

"Washizu" by James Jean & STAPLE, Produced by Mighty Jaxx (2018)

Air Jordan XI "Step'N Out" Jacket by STAPLE (2012)

KANGOL PARTNERSHIPS & COLLABORATIONS

Kangol x STAPLE Collaboration (2020)

Kangol x STAPLE Balaclava (2020)

Kangol x STAPLE Brennan Melton Wool Cap (2009)

Kangol x STAPLE Pigeon Sunhat (2009)

Kangol x STAPLE Military Knit Cap (2009)

Kangol x STAPLE Bermuda Casual (2009)

PARTNERSHIPS & COLLABORATIONS

KYX WORLD PARTNERSHIPS & COLLABORATIONS

198

KYX.World Rebranding (2019)

PARTNERSHIPS & COLLABORATIONS

199

"Jeff and the RAD team totally
reimagined the name of the company,
its look, feel and edge. They
actually came to us wanting to
explore different names, which is
a bold move, especially if they
couldn't come up with something
better. Well, needless to say,
they did — by a country mile.
Jeff's career is a master class in
embracing transition, in observing
changes in taste and trend, and in
finding a route of administration by
which his imprint can impact the
culture of the current."

Brian Mupo
Founder of KYX.World

LOMOGRAPHY PARTNERSHIPS & COLLABORATIONS

200

Lomography x STAPLE Colorsplash Chakras Camera & Book (2008)

"Cardboard" Medicom Be@rbrick by STAPLE (2010)

"10th Anniversary" Medicom Be@rbrick by STAPLE (2007)

MEDICOM PARTNERSHIPS & COLLABORATIONS

208

"1 For Equality" Medicom Be@rbrick by STAPLE & Atmos (2022)

PARTNERSHIPS & COLLABORATIONS

211

Mighty Jaxx by Danil Yad for Jeff Staple Figure (2021)

NEW BALANCE
PARTNERSHIPS & COLLABORATIONS

New Balance x Atmos x STAPLE X-Racer (2020)

NEW BALANCE PARTNERSHIPS & COLLABORATIONS

214

New Balance x STAPLE "White Pigeon" M575J (2009)

NIKE PARTNERSHIPS & COLLABORATIONS

216

FRANCHISE

NIKE BOOTS. WHERE AIR BEATS CONCRETE.

THIS IS WHERE AIR BEATS CONCRETE.

THE MEEK MAY INHERIT THE EARTH, BUT THEY WON'T GET THE BALL.

PARTNERSHIPS & COLLABORATIONS

217

Nike was the Wizard of Oz to me. It was a place that just seemed unattainable. I wasn't about to play a sport that would get me close to Nike. I wasn't an acclaimed graduate of a footwear design school that would allow me to get a job there. I was just a kid with a dream. I'd have to take the long back road in. In fact, I'd have to travel all the way to Tokyo, Japan, to get access to Beaverton, Oregon.

When I was the art director and contributing writer for *The Fader*, I convinced them to send me to Japan to write a story on how and why Nike Japan was making limited-edition sneakers for small boutiques in Tokyo. I wanted to find out why a multibillion-dollar corporation based in Beaverton, Oregon, cared about selling 36 pairs of exclusive shoes to one retail store in Japan (See page 146). It was a peculiar business story — the precursor to reselling, sneaker collecting, and street culture in general. I don't think *The Fader* team really knew what this was about, but thankfully they had faith.

I went to Japan essentially as an investigative reporter. I had zero contacts at Nike, and I didn't speak a lick of Japanese. I hit the ground running with two copies of *The Fader* in my backpack. I walked into stores and showed the managers the magazine to try to explain what I was doing. Thankfully, *The Fader* is a cool magazine, so most of the people I spoke to were into it.

I eventually worked my way up the chain at Nike to meet the guy who selects what limited shoes to make and which stores they'll go in: Marcus Tayui. I interviewed Marcus for two hours. That, along with the interview with Hiroshi Fujiwara, made it into *The Fader*. It's an incredible story.

Meeting Marcus led me to meet many key people in Japan, including Yoichiro Kitadate, Hommyo Hidefumi, and Hiroshi Fujiwara. Co-signs from these people allowed me to access the Nike World Headquarters in Beaverton, Oregon, where I began working on project after project with them. We didn't know it in the early days, but we would eventually alter the entire course of sneaker history as we knew it with the Pigeon Dunks.

—

"Jeff ended up becoming part of our content conversations. He went to Japan to write a story about Nike Japan, and he ended up interviewing Hiroshi Fujiwara. It was the first story ever written about Hiroshi in the U.S. The Fader gets a lot of credit in music, but we also did so much with style and design. The Nike Japan story was a big moment for us. We use that piece as the North Star for incorporating content outside of music."
—
Rob Stone
Co-founder of *The Fader*

PREVIOUS SPREAD:
Creative Direction - Nike ACG Advertising Campaign in Partnership with Wieden+Kennedy (2007)
Creative Direction, Production - Nike Basketball "Franchise" Magazine (2011)
Design - Nike [Co]+Lab Kit (2007)
Design, Production - Nike x Kid Robot Packaging Design (2005)
Creative Direction - Nike x Charles Barkley Advertising Campaign (2007)
Creative Direction - Nike "Streets Is Watching" Basketball Advertising Campaign (2007)
Creative Direction, Production - Nike Kobe Bryant Launch at Reed Space (2006)

Design - Nike Air Rift "Laser Pack" (2003)

Design - Nike Original Cortez "Laser Pack" (2003)

NIKE PARTNERSHIPS & COLLABORATIONS

220

Creative Direction, Design – Nike Air Burst, Shox NZ, Air Max 90 "Navigation Pack" (2004)

The Nike Considered project was one of my favorite projects I worked on with Nike, and it wasn't even a footwear design project. Richard C. and Steve McDonald handled the product design, and my job was to try and make the fairly "un-hyped" project into something that street culture kids might get behind. After all, it was their planet we were saving here.

When the project landed in my lap, it was called "Eco-Tech." I knew that needed to change immediately. Then it was called Nike "Feels Right," which felt very wrong. Part of my scope of work was penning the manifesto and mission statement. We ended up using the mission statement on the glueless, stickerless, inkless packaging that I also designed.

Each sentence in my mission statement started with the word *consider*. None of the names in the hopper were sticking, but everyone felt great about the manifesto. Someone in the group said, "Why not call it Nike Considered?" The rest is history. We then handled the Considered footwear and accessories go-to-market launches at Reed Space. It was an incredible design collaboration that spanned about two years before being put to rest.

Creating footwear and accessories that fit within the strict guidelines of what Nike considered environmentally friendly was extremely challenging. We only released about 10 styles in two years, which is microscopic for Nike. Nike eventually decided to "water down" their environmentally friendly criteria and implement those criteria into every single product they made moving forward.

They eventually named the initiative Nike "Better World," which may or may not have been the best decision depending on who you ask. I personally thought that Considered could co-exist with Better World, but maybe the upper management thought the ends didn't justify the means. I do, however, love that Nike Considered has a diehard cult following today. The designs are constantly shared and highlighted on archival websites and Instagram accounts. In some ways, this shows that we accomplished what we set out to do — create products and messaging that could stand the test of time with youth culture in the early 2000s through today.

Naming, Branding, Copywriting, Package Design, Go-to-Market Strategy - Nike Considered (2005)

PARTNERSHIPS & COLLABORATIONS

223

Nolan Knight

Nike SB Dunk "OG Pigeon" (2005)

Nike SB Dunk "What The Dunk" (2007)

Nike SB Dunk "Black Pigeon" (2017)

Nike SB Dunk "Panda Pigeon" (2019)

NIKE PARTNERSHIPS & COLLABORATIONS

226

New York Post — Wednesday, February 23, 2005

Sneaker frenzy
Hot shoe sparks ruckus
FULL STORY, PHOTOS: SEE PAGE 7

SNEAKER RIOT

PIGEON POOPED: Cops try to control the crowd of people waiting on line trying to snare a pair of Nike Pigeon (NYC) Dunk sneakers on Orchard Street yesterday after a riot broke out. Nike made only 150 pairs of the shoes, which were going for $1,000 on eBay.

Lower E. Side rumble over Nikes

"THE WORLD LEARNED THAT THERE IS A HYPE, A SECOND-HAND MARKET, AND A CULTURE TO SNEAKERS."

PARTNERSHIPS & COLLABORATIONS

227

NIKE PARTNERSHIPS & COLLABORATIONS

228

PARTNERSHIPS & COLLABORATIONS

229

Nolan Knight

Creative Direction, Design - Nike Court Force, AF1, Air Stab, Dunk "Nordic Pack" (2006)

NIKE PARTNERSHIPS & COLLABORATIONS

230

Nike SB Dunk "Just Vote" Shoe Surgeon x STAPLE (2020)

Nike SB Dunk "Purple Pigeon" (2006)

Nike Hyperfuse AM90 x STAPLE (2012)

Nike Dunk High Sabotage x STAPLE (2020)

NEW YORK CITY FOOTBALL CLUB PARTNERSHIPS & COLLABORATIONS

New York City Football Club x STAPLE Championship Season Collection (2021)

Ali Imam

New York Rangers x STAPLE Capsule Collection (2022)

THE NORTH FACE PARTNERSHIPS & COLLABORATIONS

234

The North Face for Extra Butter "Nightcrawlers" Collection (2018)

OAKLEY PARTNERSHIPS & COLLABORATIONS

236

"Collaborating and connecting with Jeff over the years has been amazing. His insight and perspective on what's going on in the world are always informative. Working on projects with Jeff is always a great journey to see what he sees coming.

My favorite project we worked on together is still the first one we did. We found the connection between Oakley's anniversary in 2010 and Jeff's 35th birthday, which was the alignment we were waiting for. The headline we chose, "A Damn Good Year," summed the collection up. It was also a feat to go beyond a single product collab and make a whole collection out of it. We worked hard to bring that story together. The products from that collection are still some of my favorites that we've released.

Of course, the crown achievement was the Pigeon Frogskins. It's still amazing that someone did a smash-and-grab at the old Reed Space shop and took off with the whole display cube that held the sample. That was just another testament to the power of the Pigeon."

Brian Takumi
VP of Product and Creative Catalyst at Oakley

Oakley Pullover Snowboard Jacket by STAPLE (2018)

Oakley "ROYGBIV" Frogskin Collection by STAPLE (2021)

OVERWATCH LEAGUE PARTNERSHIPS & COLLABORATIONS

240

I have been observing Esports for years and am a huge fan of what Overwatch League has accomplished. When they asked me to design their new kits, I was stoked. It was a once-in-a-lifetime opportunity to bring the best of the Esports and streetwear worlds together. We created something totally unique, as the kits are engineered to perform to the players' specifications while also looking great outside of the arena.

"This was a first-of-its-kind partnership and an obvious next step for the Overwatch League and the Esports space as a whole. This collaboration was a way to catapult the Overwatch League into mainstream culture while also celebrating our players and gamers, creating jerseys specifically engineered for their practicability."

Daniel Cherry
Former Chief Marketing Officer
at Activision Blizzard Esports

Overwatch League Official Team Kits by STAPLE (2020)

PUMA PARTNERSHIPS & COLLABORATIONS

Puma Suede "Create from Chaos" by STAPLE (2021)

PUMA PARTNERSHIPS & COLLABORATIONS

244

Puma NTRVL Collection by STAPLE (2017)

Puma x STAPLE Blaze of Glory (2016)

Puma Suede Classic by STAPLE (Unreleased Sample)

Puma Suede Classic by STAPLE (2018)

RAWKUS PARTNERSHIPS & COLLABORATIONS

246

DJ Spinna, "Rock" (with initial sketch idea) (1999)

Lyricist Lounge, "Volume One" (1998)

Common, "One-Nine-Nine-Nine" (1999)

Talib Kweli, "Prisoner of Conscious" (2013)

247

Rawkus Presents "Soundbombing II" (1999)

RAWKUS
PARTNERSHIPS & COLLABORATIONS

Rawkus Holiday Card (with initial sketch idea) (1998)

Early in my graphic design career, I managed to land a job at a small independent record label called Rawkus Records. They liked what I was doing early on with the STAPLE brand and wanted me to help them out as well.

I believed in what they were doing, but I had no idea that they were going to be as legendary as they were. They ended up producing some of the most important music of that era (and eventually of all time). They eventually signed Yasiin Bey (fka Mos Def) and Talib Kweli and helped create Black Star. They also put out a record with Common, Sadat X, and Company Flow. Company Flow's leader was El-P, who eventually became Run the Jewels with Killer Mike.

I started designing and producing their highly sought-after merch, including T-shirts, caps, and DJ bags. It was a small, tight-knit crew, so merch creation quickly led to helping out in other aspects like stickers, printed items, and eventually whole album packages, including one for DJ Spinna. (Shout-out Tim R., Melanie D., Jarret M., and DJ Soul).

My work at Rawkus also indirectly led me to my role at *The Fader* (page 174). Nothing happens randomly. Everything is part of a plan, but you still have to walk the path and not deviate from your calling. Common said it best, "Opportunity knocks. But he didn't call before he came." Getting my hands dirty on the ground floor of a record label that was doing this important musical work was a life-changing experience.

Black Star & Common, "Respiration" (1998)

REEBOK PARTNERSHIPS & COLLABORATIONS

250

Reebok Pump Fury x STAPLE (2022)

Reebok Pump Fury x STAPLE v2 (2022)

Reebok Club C x STAPLE (2022)

RTFKT PARTNERSHIPS & COLLABORATIONS

252

Ja Tecson

Collaborating with the team at RTFKT was my first foray into the metaverse. I dabbled a bit the year before when I dropped physical shoes on ZORA, but RTFKT was my first true NFT release.

I vividly remember DM-ing them (while I was on the toilet!), saying how impressed I was by what they were doing. I admitted that I didn't quite get it but that it gave me the same energy as when I started designing sneakers back in the day. They responded right away, and before I knew it, we were in a WhatsApp group chat talking about how we would collaborate.

Whatever eventually happens with Web3, the metaverse, and NFTs, one thing I will say for sure is that they have changed my perspective on building communities, building IP ownership, and building relationships during historic times. Thank you, C, B, and Z!

RTFKT x STAPLE "METAPIGEON" K-Minus Sneaker & NFT (2021)

RTFKT x STAPLE "METAPIGEON" NFT (2021)

RTFKT x STAPLE "METAPIGEON" MK Sneaker & NFT (2021)

Shake Shack x STAPLE (2014)

"In streetwear, collaborations are a dime a dozen, but a burger chain doing a retail and culinary collaboration is uncommon. It was an unexpected collab with a great pairing of all things New York. It was also authentic — both teams had real respect for each other's work, which helped fuel the partnership.

I would not have expected that Shake Shack would lead me to collaborate with Jeff. When I first moved to NYC, my friends and I attended parties at Reed Space. I had been a fan of Jeff's work, so it was surreal when the opportunity to collaborate with him at Shake Shack came up.

I also didn't realize that Jeff was so passionate about food, and it really showed during the process. Jeff brought a lot of ideas to the table and wanted to expand the collaboration as much as possible. He was also a great listener and took in what was important and valuable for our brand. Overall, you can tell he had a lot of fun with the project. It's great to collaborate with a person/brand that is truly a fan of Shake Shack."

Cathie Urushibata
Art Director at Shake Shack

Shake Shack x Uber Eats x STAPLE (2020)

SNEAKER CON PARTNERSHIPS & COLLABORATIONS

256

Sneaker Con Shanghai Visual Identity by STAPLE (2019)

PARTNERSHIPS & COLLABORATIONS

257

TIMBERLAND PARTNERSHIPS & COLLABORATIONS

258

Timberland x Staple 2019 Collaboration Reversible Bomber Jacket

Timberland x Staple 2019 Collaboration Field Boot

Timberland x Staple 2019 Collaboration 6" Boot

TIMBERLAND PARTNERSHIPS & COLLABORATIONS

Timberland x STAPLE Polar Night Collection

Timberland Easter Day 6" Boot by STAPLE

Timberland x STAPLE Buffalo Plaid Boros 6" Boot

Timberland x RZA Boros 6" Boot by STAPLE

Timberland Chinese New Year 6" Boot by STAPLE

"A memorable moment for me was when Jeff arrived at our factory in the Dominican Republic for Construct:10061. He came prepared with so many incredible designs and fit in seamlessly into the creation process. It also seemed like he had been working with the staff at our factory for years.

Jeff is way ahead of his time and always focused on how the end-user will interact with the product. The boots Jeff has helped us build are timeless classics, all filled with functional details that are ripe for storytelling — like the benefits of a suede boot (comfort/lighter weight) or re-imagining a 6" boot by adding a side zipper (convenience).

Another standout project we worked on together is the black denim 6" boot with a glow-in-the-dark outsole we did with RZA for the Boroughs Project in 2007. It was an instant classic and would make just as much sense today as it did almost 15 years ago.

Rarely do you get an opportunity to work with someone who is knowledgeable, respects so many aspects of culture, understands the retail playing field, and at the same time knows where to explore opportunities for a brand like ours. He is a visionary, a creator, a merchant, and a salesperson all in one."

Andy Friedman
Senior Manager of Energy at Timberland

TIMBERLAND PARTNERSHIPS & COLLABORATIONS

262

PARTNERSHIPS & COLLABORATIONS

263

TOPPS PARTNERSHIPS & COLLABORATIONS

264

Derek Jeter — New York Yankees

Shohei Ohtani — Los Angeles Angels

Mike Trout — Los Angeles Angels

Luis Robert — Chicago White Sox

Fernando Tatis Jr. — San Diego Padres

Ken Griffey, Jr. — Seattle Mariners

Deion Sanders — Atlanta Braves

Frank Thomas — Chicago White Sox

Mike Piazza — New York Mets

Aaron Judge — New York Yankees

Francisco Lindor — New York Mets

Joe Torre — New York Yankees

Vladimir Guerrero Jr. — Toronto Blue Jays

Stan Musial — St. Louis Cardinals

Cal Ripken Jr. — Baltimore Orioles

Ronald Acuna Jr. — Atlanta Braves

As a sports fan, I've collected baseball cards all of life. Topps is such an important Americana youth brand. Collaborating with them for nearly an entire year on dozens of player cards was a childhood dream come true.

TOYQUBE PARTNERSHIPS & COLLABORATIONS

266

Toyqube Pigeon by STAPLE (2021)

267

PARTNERSHIPS & COLLABORATIONS

TRETORN PARTNERSHIPS & COLLABORATIONS

268

I André Benjamin
I André Benjamin
I André Benjamin
I André Benjamin
I André Benjamin
I André Benjamin
I André Benjamin
I André Benjamin
I André Benjamin
I André Benjamin
I André Benjamin
I André Benjamin
I André Benjamin
I André Benjamin

will not draw in class.
will not draw in class.
will not draw in class.
will not draw in class.
will not draw in class.
will not draw in class.
will not draw in class.
will not draw in class.

Creative Direction for Tretorn x André 3000 (2017)

"I first met Jeff when
collaborating with Tretorn.
I had heard of this legend but was
surprised to see him at the meeting.
We worked well together and it was
very comforting to have him as a
liaison, being that I had never
done a brand collab before.

It was easy to communicate with
him and be translated in a space
where I was unfamiliar.

I witnessed a relentless drive and
open fascination to newness from
Jeff. It appears that he always
finds a way to make almost any
opportunity a positive."

André 3000
Rapper, Singer, Songwriter,
Record Producer, and Actor

VERSACE — PARTNERSHIPS & COLLABORATIONS

STAPLE
staple products

transmission

to:	
company:	
phone:	
re:	Versace Project
date:	12.18.98
pages faxed:	

Rich,

Here is the synopsis of the Versace job I just got. There is an exhibit that begins on **January 20, 1999**. That is the deadline. This is what the job is:

2,300 White Tee Shirts. I think we can do something like a Delta, doesn't have to be great. Size breakdown is **M:575 L:1150 XL:575**. It is a 1c/2c with 1c Sleeve. The front of the shirt is just a simple house with an outline like spray paint. The back is just words in 2 colors. The sleeve will be the Versace logo.

We also need label changing on this Roger. And hangtagging. And polybagging. I want you guys to do this job complete. They want to have the goods by the 18th because the **CANCEL** (and they will cancel) is the 20th. Please give me a quote by today so I can report back to them. Try to help me out with the price per garment finished because I'm not really making any money on this so anything I can make on top of your cost is my only cut....Thanks.

Peace,

jeffstaple

158 grand street suite 203 nyc, ny, usa 10013 · t – 212.941.6263 · f – 212.941.0471 · e – www.stapleproducts.com

Creative Direction for Versace & The New Museum's Exhibition of David Wojnarowicz (1999)

Around one year into starting STAPLE as a brand and design studio, I had the opportunity to work with both the New Museum of Contemporary Art and Gianni Versace on an art exhibition. I created graphics, brochures, and merch. It was huge deal for me.

I'll never forget the time I met the Versace team at their office. The security guard at the front door didn't let me in, probably because I was dressed like a derelict punk. He made me go through the back entrance. I tried explaining that I had meeting with the Versace executives, but he didn't care.

After the meeting, I walked back outside through the front door as

the Versace executives I just met with waved goodbye. The security guard had to say, "Have a good day, sir." I know he was just doing his job, but I had a huge chip on my shoulder from that initial rejection because I was so proud to be there.

If you look at the process behind this project and compare it to my childhood drawings from the beginning of the book, you might notice a similar thread. My strength is not even in creativity — it's more in my process, which I have been refining since I was a kid. This project wasn't some remarkable artistic endeavor, for example. It's more about the design process with a little bit of added flavor.

YOSHIDA KABAN / PORTER — PARTNERSHIPS & COLLABORATIONS

Porter x STAPLE 20th Anniversary Backpack (2017)

PARTNERSHIPS & COLLABORATIONS

273

I've always been a huge fan of Porter. It's a Japanese domestic brand, and it's very difficult to get outside of Japan. But in Japan, you can get Porter bags at a hardware store or at Dover Street Market. Every time I go to Japan, I pick up a new Porter bag, so collaborating with them was also an incredible personal achievement. It means a lot that I've built a brand that Porter, which is over 100 years old, is down to collaborate with.

Porter x Reed Space "PRISM" Collection (2008)

ZEE.DOG PARTNERSHIPS & COLLABORATIONS

274

"Our collaboration meant a lot, and it was memorable for both brands. It was the first time Jeff had gotten involved in the pet space, and we were the first Brazil-based brand to have ever collaborated with him. It was inspirational if I were to sum it up in one word. He's one of the most humble and kind human beings I have had the pleasure of working with."

Thadeu Diz,
Founder of Zee.Dog

Zee.Dog x STAPLE Modelled by @priusthedog (2019)

Rest in Peace to
Paulo Castro

Rest in Peace to
J. Scott

> virgilabloh
>
> ...downtown nyc & street culture in the last quarter century, through my perspective/lens.
>
> I wanted to ask if you'd be down to contributing some words for this book. I would be honored to have your thoughts and perspective included. If you're down, we can do it in a variety of different ways... You could pen something. You could send a voice memo. Or I could do a little Q+A with you and compile that into text. Whatever you're comfortable with!
>
> Let me know if you're down! Your presence in this printed work would be an incredible gift...
>
> Either way man... thank you for what you do!

SEP 15, 6:48 AM

Yeaaaa I'm down !
♥️

Rest in Peace to
Virgil Abloh

September 30, 1980 —
November 28, 2021

Jeff Staple: Not Just Sneakers
Copyright ©2022 Jeff Staple

Text contributions in order of appearance: Jeff Staple, Roy Choi, Mark Rosati, Futura, Nick Woodhouse, Tim Brown, Johanna De Los Santos, Hommyo Hidefumi, Scott Patt, Darren McKoy, Rob Stone, Hiroshi Fujiwara, Lyndon & Jamie Cormack, Kevin Ma, James Jean, Brian Mupo, Asako Saito, Daniel "Mache" Gamache, Brian Takumi, Daniel Cherry, Cathie Urushibata, Andy Friedman, André 3000, Thadeu Diz.

For Jeff Staple and Reed Art Department:
Editor: Emily Suzuki
Creative Direction: Reed Art Department
Art Direction: Brent Rollins
Design: Pres Rodriguez
Editorial Coordination: Elizabeth Ishii
Contributor: Tamanna Chowdhury
Product Photography unless otherwise credited: Shinji Murakami
Creative Support: Jonathan Rodriguez
Special Thanks: Jessica Almonte, Tracey Bui, Kim Caban, Sarah Gladstone, Mike Hamane, Kevin Hong, Ali Imam, Shu Jones, Abigail Kim, Matthew Novoselsky, Matthew Ostergaard, Christian Perez, Nico Reyes, Fabio Scalici, Alasdair C. Thompson, Brandon Washington, Amy Wright, Prius The Dog and Michael Reed.

Cover Sheet Photography: Jason Lewis
Cover Retouching: Joseph Girardi/ Q Studios

For Rizzoli:
Publisher: Charles Miers
Editor: Ian Luna
Project Editor: Meaghan McGovern
Design Coordination: Olivia Russin & Eugene Lee
Production Manager: Barbara Sadick
Copy Editor / Proofreader: Mimi Hannon

Rizzoli Acknowledgments:
Rizzoli would like to thank Jeff Staple, Elizabeth Ishii, Brent Rollins, Matt Novoselsky, and Hiroshi Fujiwara.
—Ian Luna

All rights reserved. No part of this publication may be reproduced, stored in a retrieval system, or transmitted in any form or by any means, electronic, mechanical, photocopying, recording, or otherwise, without prior consent of the publishers.

Every effort has been made to gain permission from copyright holders and or photographers, where known, for the images reproduced in the book, and care has been taken to caption and credit those images correctly. Any omissions are unintentional and appropriate credit will be included in future editions if further information is brought in writing to the publisher's attention.

Printed in China

2022 2023 2024 2025 2026 / 10 9 8 7 6 5 4 3 2 1

ISBN: 978-0-8478-7133-9
Library of Congress Control Number: 2022939335

Visit us online:
Facebook.com/RizzoliNewYork
Twitter: @Rizzoli_Books
Instagram.com/RizzoliBooks
Pinterest.com/RizzoliBooks
Youtube.com/user/RizzoliNY
Issuu.com/Rizzoli

"I just wanna know how

the *Pigeon* represents New York all of a sudden?"